Cover:
JOHN LA FARGE (1835-1910) and AUGUSTUS SAINT-GAUDENS (1848-1907)
39. **Apollo with Putti** (Detail)

DANIEL CHESTER FRENCH (1850-1931)
23. **Spirit of Life**

The Arts of
the American Renaissance

April 12–May 31, 1985

Hirschl & Adler Galleries, Inc.
21 East 70th Street, New York, N.Y.

ACKNOWLEDGEMENTS

In addition to thanking the lenders to this exhibition and several members of the Hirschl & Adler staff, acknowledged by Mr. Feld in his "Foreword," we would also like to express our appreciation to others outside of the gallery who helped to bring this show and its catalogue to fruition. Certain individuals have supplied information on specific works of art; their names appear in the text of the catalogue and to them we are indebted. We would also like to thank David Adams, Historian for the Lamb Studios, Spring Valley, New York, Robert Bahssin, Post Road Gallery, Larchmont, New York, Elizabeth Evans, New York, D. Roger Howlett, Childs Gallery, Boston, Massachusetts, William H. Gerdts, City University of New York Graduate Center, James Maroney, New York, Sean McNally, Ridgewood, New Jersey, Louis A. Rachow, Curator and Librarian, The Players, New York, and Sandra Tatman, Architectural Librarian, Atheneum of Philadelphia, Pennsylvania.

D.D. and S.E.M.

FOREWORD

Perhaps more than in any other period in the history of American art, the fabric and appearance of our cities was given a sense of monumentality and permanence during the age of the American Renaissance. From the grandiose schemes for Grand Central and Pennsylvania stations, the Fifth Avenue facades of The Metropolitan Museum of Art, the New York Public Library, and the New York homes of Henry Clay Frick and J. Pierpont Morgan, to the correspondingly elaborate and classically inspired Civic Center (*cf.* no. 26) and The Fairmont Hotel, both in San Francisco, and the Huntington Gallery and Library in San Marino, California, the complexion and scale of our great cities changed dramatically during the decades between the Philadelphia Centennial Exposition of 1876 and the years immediately following World War I, when the lingering forces of the Beaux-Arts style were gradually transformed into a cleaner, more linear idiom inspired by the functional modernism of the 1920's. Never before had so many talented architects, sculptors, and painters collaborated with each other so effectively to create so harmonious a style and to give form and character to our American cities. Whether we specifically recall Cass Gilbert's great State House that towers over the city of St. Paul, Minnesota (*cf.* no. 21), or the Jefferson Building of the Library of Congress in Washington, D.C., designed by Smithmeyer and Peltz and completed by Edward P. Casey, is less important than the fact that many of us partake daily of a way of life set against a backdrop created during the American Renaissance. Our statehouses, our railroad stations, our post offices, our apartment houses, our clubs, and the commemorative monuments in our parks and public places frequently date from this period and have established the essential character and look of many of our cities. Although, like many of the monuments of Lewis Mumford's "Brown Decades" that disappeared before they could be properly assessed by future generations, some of the great architectural and decorative projects of the American Renaissance have been victims of the wrecker's ball—in New York, McKim, Mead, and White's Pennsylvania Station of 1902-11 comes first to mind. Others have fortunately survived and are now protected under "historic landmark" designations that insure that the Beaux-Arts quarters of our great cities will not wholly give way to the vaster and vaster buildings projects of our own time.

The Arts of the American Renaissance is an attempt to recall both the great architectural and decorative projects and the more intimate artistic creations of a fascinating period in the history of American design. Although it is not possible to recreate at Hirschl & Adler events such as the World's Columbian Exposition and the Panama-Pacific International Exposition, both of which so profoundly affected the way people looked at architecture and at themselves, by studying views by Theodore Robinson (no. 64) and Childe Hassam (no. 30), and the mural study by Walter Shirlaw (no. 70) on the one hand, and Robert Reid's studies for the murals in the Palace of Fine Arts (nos. 63a-e) and Adolph Weinman's reductions of *Rising Day* and *Descending Night* (nos. 82a and 82b) on the other, we gain something of a glimpse of those landmark events in the evolution of American taste. Similarly, mural studies by Frederick Dielman (nos. 17 and 18),

Robert Reid (nos. 62a-e), and Elihu Vedder (no. 78) for the extensive decorations of the Library of Congress stand as evidence of the quality and complexity of that enormous project. And although the panel from the ceiling in Cornelius Vanderbilt II's house by John La Farge and Augustus Saint-Gaudens (no. 39) and casts of working models or reductions of such monuments as Saint-Gaudens' figure of *Victory* (no. 66) from the *Sherman Monument*, Daniel Chester French's *Spirit of Life* (no. 23) from the *Spencer Trask Memorial*, and William Ordway Partridge's *Homer Reading the "Iliad"* (no. 59) give a very incomplete picture of the glamour and artistic responsibility of the American Renaissance, they nevertheless help us to comprehend the considerable and diverse talents that came together in this brief era to create a style that has so profoundly affected the look of American cities.

* * *

The Arts of the American Renaissance represents the collaboration of many members of the Hirschl & Adler staff, but without the dedication and considerable labors of Susan E. Menconi, Director of our Department of American Sculpture, and Douglas Dreishpoon, our Curator of Exhibitions, the "idea" of the exhibition would neither have been given its present form, nor would this catalogue have so capably documented its contents. The catalogue descriptions for most of the works included were prepared by Mr. Dreishpoon and Ms. Menconi, but other entries have been written by Kathleen Burnside, Sandra K. Feldman, Martha Parrish, and Meredith Ward of the Hirschl & Adler staff.

All works shown are from the Hirschl & Adler collections, with the exception of the beautiful and sensitive *An Arcadian* by Thomas Eakins (no. 20), the mellifluous frieze by Robert Blum (no. 4), and the shimmering Theodore Robinson *World's Columbian Exposition* (no. 64), to whose owners we are extremely indebted for making their works available to us.

February 27, 1985 Stuart P. Feld

INTRODUCTION

Between 1876 and 1920 American art developed out of a complex amalgam of social, political, and artistic currents. Within this cultural matrix, the arts of architecture, painting, and sculpture profoundly influenced the basic fabric of daily life. In a period when America was searching for national identity after the divisive Civil War, amidst unprecedented industrialism and eclecticism, the artist shaped and visualized the hopes and aspirations of an entire nation. If the fruits of a progressive materialism today appear problematic, by the turn-of-the-century industrialism and commercialism were optimistically sanctioned; material progress was embraced as the way of the future. In general, artists of the period not only accepted "progress," but formulated an iconography that grounded contemporary developments in allegory and personification. If America by the 1890's appeared to be changing at an unsettling rate, the arts, taking refuge in the past, propagated a formal aesthetic that elevated material change to the realm of timelessness and ideality.

The period of American culture known as the American Renaissance gave rise to a community of artists, largely New York-based, whose ideological objective was to unify the arts. In developing their own cultural iconography, artists studied examples set forth by earlier European cultures—ancient Greece and Rome, and fifteenth century Italy. As historic prototypes, these models came to symbolize leisure, erudition, and high culture; their appropriation was heralded by influential art critics, historians, and wealthy patrons. By the 1860's American art students were inspired to study these models firsthand, or to acquire a theoretical foundation through European academies and *écoles*. By the 1870's Paris, with its own burgeoning cultural renaissance, not only offered a contemporary model, but provided a highly developed educational system—the Ecole des Beaux-Arts and numerous private ateliers.[1]

Recalling his youth in Albany, New York, during the late 1860's, the American painter Will H. Low recounted his first experiences with art as a lecturer at the Art Institute of Chicago.[2] As a close friend of another American painter Walter Launt Palmer, he had gained access to the studio of Palmer's father, the sculptor Eratus Dow Palmer. The elder Palmer, unlike his contemporaries Hiram Powers, Horatio Greenough, and Thomas Crawford, had never studied in Europe, and he admonished the aspiring artist to study nature at home, for here was the inspiration that produced original art. At a time when American students were discovering the benefits of a European education, Low recalled the sculptor's fraternal advice: "Study nature, and above all keep a tight grasp on your originality."[3] However, like many of his own contemporaries, Low did go to Europe, and his decision to do so highlights a significant change of attitude that altered the development of American art over the next fifty years. If Palmer's ambivalence towards European influences reflected the attitude of many artists prior to the Civil War, Low's acceptance of these same influences paralleled the feelings of the many American architects, painters, and sculptors who sojourned in Paris, and also in London, Düsseldorf, Antwerp, and Munich, for inspiration and training during the 1870's and 1880's. The transition from provincialism to pan-international

professionalism, accelerated by the Philadelphia Centennial Exposition of 1876, provided the conceptual basis for an American Renaissance.[4]

American students traveled to Paris to study art and in the process became cosmopolitan. Art was taught in tandem with literature, history, and religion, the requisites of a liberal education; the student not only mastered the essentials of his craft, but approached the discipline historically, surveying earlier periods for their continuity. Acknowledging the diversity of a late-nineteenth century "French" education, the fundamental distinctions of this "school" included an emphasis on technique, in particular drawing and figure construction, a professionalism that enabled artists to work in various media, and an eclectic approach to style and content.[5] Perhaps more than any other aspect, eclecticism generated the range and diversity of American Renaissance art, its heterogeneous mix of allegory, mythology, history, exotica, and contemporaneity. Not at all random or indiscriminate, late-nineteenth century eclecticism was a selective process, the appropriation of specific "types" of style, composition, and content, and their synthesis in a modern context. The history of art was conceived as a dynamic continuum. American students, after completing intensive programs that sometimes lasted for up to four or five years, returned to the United States with lofty ideals, but pragmatic about the necessity of having to support themselves.

The auspicious arrival of the first wave of students returning from Paris and Munich during the mid-1870's sparked dissension and controversy at the same time it signalled a new direction for American art. A "new breed" of architects, painters, and sculptors, whose progressive attitudes and impeccable training represented the best of what Europe had to offer, were often met with disdain and rejection by older academicians. Disappointed and enraged by the National Academy of Design, particularly its restrictive policies and unfair representation, several artists formed the Society of American Artists (1877) and gathered around them forces that shaped the American Renaissance.[6] Ironically, in spite of its initial idealism and progressive momentum, the Society later merged with the Academy in 1906. At the time, however, this group of artists represented the hope and the new blood of American art, and they set about to affect art and culture.

The return of American students from Europe during the 1870's and 1880's coincided with nation-wide expansion and growth. By this time, the Western Frontier was beginning to give way to homesteads; burgeoning towns and cities fostered a vast architectural expansion—state and municipal edifices, a profusion of schools, hotels, city halls, courthouses, libraries, and an array of commemorative monuments. Any discussion of painting and sculpture as they developed from this period into the first decades of the twentieth century must acknowledge an architectural renaissance that set the pace for major sculptural and decorative commissions. Architects such as Daniel H. Burnham, Arnold W. Brunner, Cass Gilbert, Richard Morris Hunt, Charles Follen McKim, and Stanford White, many of whom had also studied in Paris at the architectural ateliers of the Ecole des Beaux-Arts, patterned their buildings after ancient Greek and Roman, or Renaissance prototypes and, in essence, provided spaces for ornamentation with painting and sculpture.

In their ability to organize collaborations, to decide which artists contributed what to a decorative program, the architect wielded considerable power and influence. In a letter to Kenyon Cox of 1901, Will Low referred to the "God like architect who directs the destiny of a decorative painter," and Edwin Blashfield, in his book *Mural Painting in America* (1913), devoted a chapter to the "mutuality between architect and mural painter."[7] In general, the architect's designs, frequently elevated to art by architectural delineators such as Jules Guerin (no. 26), were embellished by painters, sculptors, and decorative artists. While some flexibility was possible in the choice of a particular subject, the architectural design ultimately determined the formal character and dimensions of the work to be housed both inside and out. Most artists quickly assimilated the dynamics of this rapport, which frequently entailed memberships in the right clubs and social establishments.[8] In their desire to transcend the whimsical demands of the art market and to place their work permanently within public spaces, artists not only embraced the idea of collaboration, but found immeasurable pleasure and security in working this way. United, the arts of architecture, painting, and sculpture formed an invincible triad whose potential was inspiring. Those artists who returned from France before 1880, having witnessed

the revival there of mural painting together with architecture and sculpture, believed that a similar renaissance could be initiated in America. However, apart from a few public projects and intermittent private commissions, the full realization of this dream took more than twenty years to materialize.

When the World's Columbian Exposition in Chicago, Illinois, opened to the public on May 1, 1893, its grandiose scale, collaborative design, and classical orientation symbolized a coming of age for American art. Augustus Saint-Gaudens, after an early planning session for the exposition, exclaimed: "This is the greatest meeting of artists since the fifteenth century!"[9] And, in 1910, Will Low reminisced about its historic significance:

> When the White City was built in 1893, art assumed a definite place in our national life. Then for the first time we awoke to a realization that art of the people, by the people, for the people had come to us. It came to this New World of ours in the old historic way. From seeds sown in the Orient, through Greece, through Italy from Byzantium, wafted ever westward, its timid flowering from our Atlantic seaboard had been carried a thousand miles inland to find its first full eclosion; not as a single growth, but as the triple flower of architecture, painting, and sculpture.[10]

Depictions of the World's Columbian Exposition by Childe Hassam and Theodore Robinson (nos. 30, 64) celebrated this grand event. In retrospect, they not only represent historical documents, but are signs of a classic sensibility that affected American art and architecture for the next twenty years. The public success of the White City spawned an architectural model and a collaborative approach that rapidly became the standard for state and municipal planning—the City Beautiful Movement Within this orientation, cultural advancements were endowed with a classical order whose derivation was distinctly European.

Amidst national depression during the 1890's, a wealthy class of patrons emerged whose financial exuberance and eclectic tastes spearheaded the American Renaissance. Howard Mumford Jones noted early on the affinities between Italian merchants and bankers of the Renaissance and their American nineteenth century counterparts, the robber barons and industrialists.[11] The Huntingtons, Goulds, Fiskes, Clarkes, Stanfords, Rockefellers, Carnegies, Guggenheims, Morgans, Pulitzers, Mellons, and the Vanderbilts, in the days before the New Deal, became the trend setters, whose gilded tastes and infatuation with Renaissance models was precursed by scholarly discourse, the writings of James Jackson Jarves, Charles Eliot Norton, and Jakob Burckhardt[12]. However, extravagant wealth—the fruits of industrialism and material prosperity—coexisted with mass social ills, poverty, and degradation. "The Gay Nineties," as Neil Harris noted, "were the Depressed Nineties for millions of contemporaries."[13] An obvious discrepancy between the lower classes and an elite, influential class of patrons and benefactors raises a curious paradox, evident if one compares the classical ideals of Kenyon Cox, Augustus Saint-Gaudens, and Charles Follen McKim with the stark realism of photographers Lewis Hines and Jacob A. Riis. Artists of the American Renaissance were aware of culture's other, darker side, but they chose to celebrate its successes rather than underscore its failures. Their objective was not social reform per se, but the glorification of history. Optimistically, they sought to affect national consciousness by emulating the classicism of ancient Greece and Rome, and their Italian progeny. In the spirit of such artistic predecessors, Americans celebrated their own national heroes. Revolutionary and Civil War figures—George Washington, Nathan Hale (no. 46), Abraham Lincoln (no.22), William Tecumseh Sherman (cf. no. 66), Robert G. Shaw, et al.—found their way into the sculptural imagery of the period and reflected the zealous patriotism of a young and confident nation. *The Dewey Arch,* depicted by Everett Shinn (no. 69), and *The Maine Monument* by Atillio Piccirilli (1913), Columbus Circle, New York, symbolize the apotheosis of imperialism that drove America beyond its domestic problems, and reflect the positivism that dominated art and politics during this period.

Artists, like politicians, measured their own accomplishments against that of history. Admiral George Dewey's triumphal return in 1899 from Manila Bay in the Philippines was paralleled in the arts by artists who had returned earlier from Europe bearing booty in the form of sophisticated technique, cosmopolitan erudition, and a new sense of purpose. Their confidence reflected evolutionary theories based on natural selection and survival.[14] Eclecticism was scientific when explained through principles of adaptation, regeneration, and assimilation; "technic" embodied a synthesis of academic study, history, and contemporaneity.

If the quest for power and historical significance in the political realm frequently assumed the proportions of imperialism and commercial exploitation, within the arts, political motivation was superseded by the desire for new cultural experiences and exotic subjects. By the 1890's the American Indian coexisted with the Samoan chief, Moroccan concubine, and Japanese geisha. The strong influence of exotica on many American artists during this period was in part a result of Parisian training. Henry Siddons Mowbray's *The Harem* (no. 58), Albert Herter's *Two Women* (no. 32), and Charles Winter's *A Sphinx* (no. 83) were more the result of a personal fascination with this genre—popularized as early as the 1820's by Eugene Delacroix and sustained by the influence of Jean-Léon Gérôme—than a prolonged, firsthand exposure to these cultures. Other American artists, however, traveled extensively. John La Farge's *Presentation of Gifts* (no. 42) and Robert Blum's *A Siesta* (no. 6), executed in Samoa and Japan, respectively, represent actual encounters. Both artists, working in the spirit of contemporary anthropologists, transcribed customs within cultures and observed life around them with sensitivity and insight. Foreign cultures provided the impetus for an iconography outside the mainstream of Western art. Enhanced by their popular demand, exotic subjects offered a venue for a nation's dreams and fantasies; as a means of escaping one's own time and culture, they furnished a rich alternative to classical allegory, mythology and history.

While some American artists during this turn-of-the-century period took the initiative to study non-Western cultures firsthand, they and their colleagues still believed that America was a land of opportunity, with numerous challenges that enlisted the participation of architects, painters, sculptors, and decorative artists. For the sculptor, now able to create his images in bronze unhindered by the limitations of marble, the possibilities and commissions seemed endless. In an age of wealth and prosperity, the call for sculptural decoration was enormous. Commissions ranged from elaborately conceived public monuments, symbolic grave memorials, and fanciful outdoor fountains, to portraiture, ecclesiastical imagery, and small-scale works intended for the home. Saint-Gaudens, who had assimilated the teachings of the ancients and their fifteenth century offspring, was a master innovator. His first major commission, *The Farragut Monument,* unveiled in 1881 in Madison Square Park, New York, heralded a new direction in American sculpture and can be seen as the first important break with Romantic Neo-classicism. The monument had life and spirit; its pedestal, created in collaboration with Stanford White, recalled Italian Renaissance benches, while Farragut himself was derived from Donatello's *St. George* (Orsanmichele, Florence, Italy). The female figures in bas-reliefs representing "Loyalty" and "Courage" introduced a new level of ideality and allegory, which also found expression in such other works of the period as Daniel Chester French's *Spirit of Life* and *Wisdom* (nos. 23, 21), Adolph Alexander Weinman's *The Rising Day* and *Descending Night* (nos. 82a, 82b), and Saint-Gaudens' own *Victory* (no. 66). It was a great age for sculpture. The American expositions—most importantly Chicago in 1893, but also Buffalo in 1901, St. Louis in 1904, and San Francisco in 1915—called for more sculpture on a grander scale than had ever before been thought possible, and the sculptors of the American Renaissance rose to the challenge. The impact of the White City, with French's sixty-five foot gilded figure of *Republic,* Frederick MacMonnies' enormous and elaborate *Barge of State,* Saint-Gaudens' elegant, golden *Diana* surmounting the dome of the Agriculture Building, amongst hundreds of other mythological and symbolic creatures, reached out to Americans across the United States and generated an unprecedented demand for sculpture. By the time the San Francisco exposition opened in 1915, it seemed as if there was a monument in every town square, decorative statuary on every public building, and small sculptures or bas-reliefs in every wealthy home.

For the painter, the monumental mural opened a whole new field of endeavor John La Farge's extensive program for Trinity Church, Boston, Massachusetts (1876-78), and William Morris Hunt's murals *Columbus* and *Anahita* for the Assembly Chamber of the Albany State Capitol, New York (1878), not only set the standards for subsequent projects, but inspired younger artists such as Will Low, Kenyon Cox, and Henry Siddons Mowbray to be optimistic about the future of this métier. In actuality, until the World's Columbian Exposition, La Farge's and Hunt's murals remained for the most part insular innovations, but after 1893 and until about 1920, mural painting found its materialization in a large percentage of state and municipal buildings, and select private residences, from Maine to Florida, from New York to San Francisco.[15] Because of its

novelty, mural painting generated a vast body of critical literature. Artists and critics appraised its objectives and debated its style and content. Believing that mural painting had made a significant contribution to American art by 1917, Kenyon Cox wrote:

> If America has produced no mural painter of such lofty talents as Puvis de Chavannes or Paul Baudry, she has yet, within twenty-five years [1893-1917], developed a whole school of mural painters such as exists nowhere else ... In many fields America has been developing a native art, independent of that of other countries—an art inherited, indeed, from the past but modified by American temperament and suited to American needs ... In no field have American artists more decisively taken their own way than in this of mural painting, in none have they produced an art more their own. And perhaps that which is most characteristically American in this art is its conservatism, its discipline and moderation, its consonance with all great and hallowed traditions—in one word, its classicism.[16]

Mural painting was valued for its ability to educate, to illustrate history, and to elevate culture. Its importance was defended on the grounds of patriotism and moral commitment:

> The decoration of public buildings is the most important question in the consideration of ... art of the future, just as it always has been in the past of any and every national art from the time of the pyramid-builders down. Indeed, it passes far beyond the question of art to the questions of morals and patriotism and general morals.[17]

Before an age of electronic media and television, murals and sculptural monuments embodied the nation's history, hopes, and aspirations—its psychological center.[18] Cultural symbols—virtues personifying justice, peace, victory, wisdom, freedom, life, death, prosperity, law, discord, industry, the sciences, the continents, etc.—were conceived as universal principles and reflected changes in social ideals and cultural progress.[19] The message often took the form of carefully constructed allegorical narratives and symbols—usually female—personifying timeless ideals. While the content of these works varied with the commission (private commissions offered greater flexibility and often reflected the personal tastes of the patron), the basic iconography had been established by the eighteenth century.[20] Abstract ideals and technology found their expression through personifications derived from history, literature, and mythology, which in turn were based on classical and Renaissance prototypes. Thus, Saint-Gaudens' *Victory* (no. 66) from the Sherman Monument shows a familiarity with the Hellenistic *Nike of Samothrace* (Louvre, Paris), while the equestrian figure of Sherman himself is allied with Donatello's *Gattamelata* (Piazza del Santo, Padua, Italy) and Verrocchio's *Colleoni* (Campo dei SS. Giovanni e Paolo, Venice), themselves drawn from the ancient Roman *Marcus Aurelius* (Capitoline Hill, Rome). Jonathan Scott Hartley's *Lawrence Barrett as "Cassius"* (no. 28) draws inspiration from ancient Roman portrait busts, while MacMonnies' *Young Faun and Heron* (no. 50) takes something from both Donatello's *David* (Bargello, Florence) and Verrocchio's *Putto with Dolphin* (Palazzo Vecchio, Florence). French's *Wisdom* (no. 21) evokes archaic Greek Kore figures, and Saint-Gaudens' *Robert Louis Stevenson* (no. 65) and MacMonnies' *Susie Pratt Kennedy* (no. 47) reveal familiarity with Renaissance medals and bas-reliefs. While the sources were often classical, the interpretation of these models was contemporary.

Given the opportunity, mural painters also studied Italian Renaissance prototypes directly. Henry Siddons Mowbrary, on the recommendation of Charles Follen McKim, copied Pintoricchio's murals in the Apartment of Alexander VI, in the Vatican, Rome. Kenyon Cox and Edwin Blashfield, both of whom knew Italian sources firsthand, from anonymous masters to Raphael, Michelangelo, Titian, and Veronese, cited these throughout their writings as classic examples of mural painting. And Elihu Vedder, who lived much of his life in Rome and Capri, was intimately familiar with Renaissance programs. The major influences during the 1870's and 1880's, however, were French. Paul Baudry's cycle for the Paris Opera (1874), murals by Puvis de Chavannes, Jean Paul Laurens, Alexander Cabanal, Pierre Victor Galland, and Léon Bonnet, installed in the Panthéon about 1877, as well as other murals by Puvis de Chavannes, Jean Paul Laurens, Jean-Joseph Benjamin Constant, and Léon Bonnet in the Grande Salle des Fêtes, Hôtel de Ville, and by Eugene Delacroix at Saint-Sulpice, Paris, represented a broad spectrum of contemporary approaches to this métier.[21]

During the American Renaissance, artists brought to their respective diciplines an encyclopedic knowledge of art and art history, and developed an extended range of subjects.

Frederick Dielman's *History* and *Law* (nos. 17, 18), Daniel Chester French's *Wisdom* and *Spirit of Life* (nos. 21, 23), Walter Shirlaw's *Electricity, Industry, Commerce,* and *Transportation* (nos. 71a-d), and Elihu Vedder's *Study for "Government"* (no. 78) are allegorical idealizations of timeless principles. The proposed setting for a particular program played an important role in determining its subject and execution. Vedder, for example, selected his subject for its compatibility within the larger program, *Government,* the panels for which were installed in 1896 above the entrances to the House Reading Room in the Library of Congress, Washington, D.C. Daniel Chester French's *Wisdom,* together with its companions, *Truth, Bounty, Prudence, Courage,* and *Integrity,* reflected idealistic aims for legislation in the State Capitol Building in St. Paul, Minnesota. Other artists based their subjects on mythological themes. Karl Bitter's *Pomona* (no. 2), Albert Herter's *Mural Study* (no. 33), Frederick MacMonnies' *Diana* (no. 45), Francis Davis Millet's *Thesmophoria* (no. 54), H. Siddons Mowbray's *Ceiling Study* (no. 59), and Robert Van Vorst Sewell's *Psyche's Wanderings* (no. 68) demonstrate the extent to which mythology had become a storehouse of ideas. Also related to mythology, neo-pagan subjects, frequently based on bacchanalian rites and initiations, were given contemporary interpretations, as in Harriet Frishmuth's *Sweet Grapes* (no. 24), Frederick MacMonnies' *Bacchante with Infant Faun* (no. 49), and F. Luis Mora's *Woodland Carnival* (no. 56); cosmology and the zodiac were important aspects of Elihu Vedder's work, as seen in his *Design for Mantelpiece* (no. 79).

Conscious of their work's contemporaneity, many painters and sculptors fostered a feminine ideal that was both symbolic and modern. Robert Reid's studies for *The Five Senses* (nos. 62a-e) gave allegorical painting a distinctly contemporary twist by fashioning a type of beauty based on ideal models and popular stereotypes created by contemporary illustrators such as Charles Dana Gibson, Jessie Willcox Smith, and Howard Chandler Christy. A concern with ideality and contemporaneity spawned a proliferation of private images, easel pictures and small-scale sculptures that often elevated the female to purity and spiritual timelessness. Works such as Thomas Wilmer Dewing's *Lady in Green* (no. 14), Bessie Potter Vonnoh's *The Fan* (no. 81), Will H. Low's *Basket of Oranges* (no. 44), and Robert Reid's *A Breezy Day* (no. 61), represent only a few of the many guises this motive assumed and reinforce the central importance of the woman in a late-nineteenth century imagination.

The professional mural painter and sculptor accepted their role as decorators, because, to function successfully, their work had to harmonize within its architectural/environmental setting. For them, the unification of the arts within a larger ensemble was a form of liberation. Individuality—crucial to the later development of modernism—assumed an entity that was the sum total of its collaborative parts. The decorator was in an enviable position, because, according to Will Low, his audience was the public:

> The world has seen many great easel pictures, many single statues and groups full of import to humanity; with the thought of many such strong in my memory, I am constrained to believe that the truly great art of the past and that of the future depends on that intermarriage of beauty and use, which alone exists in decorative art. . . . The decorator, in a word, works for the world; his production, no longer conceived for the stifling atmosphere of a studio or gallery, breathes the open air; and art, instead of being as it is too often a thing apart, becomes a portion of our daily life. . . .[22]

A burgeoning market for decorative commissions, coupled with an efficiency made possible through collaboration, gave rise to workshops whose philosophical objectives and internal organization varied considerably. John La Farge, surrounding himself with talented young artists, patterned his workshop after the traditional Italian "bottega" and designed and executed stained glass, architectural ornament, murals, sculpture, and embroideries. Though the number of individuals he employed at any given time varied with the commission, La Farge, always sensitive to the overall harmony of his ensemble, directed the activities of his workshop closely. For this reason, his domestic commissions for the Union League Club (1880-81), and the Vanderbilt houses (1881-82), in New York, and the Ames houses in Boston, Massachusetts (1881, cf. no. 38), as well as his ecclesiastical commissions for the Church of the Incarnation (1885) and the Church of the Ascension (1886-88), New York, were some of the most successfully integrated programs of their kind. Recognized during his lifetime as both a teacher and trend setter, La Farge was highly respected for his imaginative designs, experimentation with mixed-media, and artistic integrity.

Time and money aside, he consistently labored to give his decorative programs a personal quality that transcended the oftentimes repetitive designs of some of his contemporaries.

While La Farge for the most part maintained a small but efficient workshop, others, following his lead, expanded into mass production and specialization. Louis Comfort Tiffany launched his career with the Associated Artists (1879-83).[23] During its brief tenure, the Associated Artists completed major decorative commissions for the Union League Club (1880), and The White House, Washington, D.C. (1882). As with other workshops, a division of labor was instituted. Tiffany was in charge of stained glass, Candace Thurber Wheeler, textiles and embroideries, Lockwood de Forest, carving and wood decorations, and Samuel Colman was made Director of Color. When the firm disbanded in 1883, Tiffany continued to work almost exclusively in stained glass and generated a thriving business whose prolific production of glass matched the demands of a consuming market. Combining landscape and floral motives with the stylized simplicity of Japanese art, Tiffany's studio produced pieces such as *Wisteria Diptych* (no. 74). His ability to synthesize successfully popular styles in various lines of fine glass objects was a sign of his artistic and commercial genius.

While decorative collaborations were applauded for their ambitious scale and potential, some artists were more sensitive to their possible pitfalls and shortcomings, particularly if commercialism threatened to undermine the integrity of an ensemble. As early as 1893, La Farge expressed his concern over this matter:

> Even the destruction now forced by what is called commerce, upon all those branches of art, which, being worked collectively, by many people together of different grades, are specially liable to disturbance which no individual devotion, no individual high-mindedness can check; which also being mechanism, can be made into organizations entirely ruled by the commercial spirit—even these injuries, these degradations, may have an end, when again it may become the interest of what is called commerce to thrive by the rivalry of doing well.[24]

Considering his apprehensions, La Farge was optimistic that competition would ultimately inspire quality. If the American Renaissance produced a generation of artists-cum-entrepreneurs, the overall quality of decorative art was still impressively high. In spite of public demand, the major workshops of Tiffany, J. & R. Lamb, and Nicola D'Ascenzo, to name just a few, maintained a tradition of craftsmanship while they manufactured art for the thousands.

As the twentieth century progressed beyond the 1920's, social and artistic changes undermined the classical orientation that had characterized the American Renaissance. In a modern age of technology and individualism, lavishness and collaboration gave way to functional simplicity and specialization. Architectural design underwent conceptual transformations; functionalism superseded embellishment. When architects began to change their concept of design and materials, eliminating the wall niches and enframed spaces that had earlier housed murals and sculpture, the decorative arts lost their *raison d'être*. Industrialism demanded clarity and precision rather than allusion and metaphor. In the "Jazz Age," personification and allegory seemed anachronistic; in the wake of modern art, with its rapid succession of stylistic changes, art of the American Renaissance appeared out of touch with vital forces of contemporary life.

The streamlined sculpture of Paul Manship represents a conscious move away from Beaux-Arts naturalism to a more abstract, stylized conception of form. He looked to new sources of inspiration—archaic Greek, Oriental, and Hindu statuary—to formulate a "modern" sculptural equivalent. His continued emphasis on figuration and personification, however, allies him with the American Renaissance; in sculpture, he could be considered the last link to what Kenyon Cox called "The Classic Spirit." Mural painting, as it continued into the 1920's, was problematic. Eclecticism still characterized major programs, but work by Eugene Savage, for example, appears more decadent than innovative. Bright Fauvist colors and activated, angular composition, when combined with traditional allegory, often seem incongruous. By the late 1920's the rational, didactic order espoused by Kenyon Cox had given way to personal symbolism, abstraction, and experimentation.

Later critical opinion condemned the American Renaissance for its estrangement from fundamental social issues; with fresh eyes, Lewis Mumford resuscitated "modern" personalities such as Louis Henry Sullivan, Albert Pinkham Ryder, and Thomas Eakins, innovators, whose

contributions, to his mind, had been glossed over by the materialism and ostentation of the previous era. According to Neil Harris, by the 1930's, "the Gilded Age had become, for a whole generation, the symbol of a national loss of innocence and quest for wealth, its politics corrupt, its art and literature a pale degeneration from the heroic days of New England's dominance."[25] But the Gilded Age was not without its accomplishments, and though Mumford focused on "master spirits" of "isolated genius," he also acknowledged its quest for artistic unity. If today fragmentation and specialization fracture our visual perception of the world, the American Renaissance symbolized a time in American culture when art celebrated the holistic quality of life.

March 7, 1985

Douglas Dreishpoon
Susan E. Menconi

NOTES

1. For the sculptor, Paris offered a practical advantage, as well as an aesthetic one. There was a long tradition of bronze sculpture, and, more importantly, many bronze foundries at which to have work cast.

2. Will H. Low, *A Painter's Progress* (1910)

3. Low, "The Awakening of Vocation," in *ibid,* p. 39

4. This transition had actually begun earlier, on a more selective basis, with John Singleton Copley and Benjamin West to London, England, in the third quarter of the eighteenth century, the American neo-classical sculptors to Rome and Florence, Italy, from the late 1820's on, and American painters to Düsseldorf, Germany, during the 1850's.

5. H. Barbara Weinberg, "Late-Nineteenth-Century American Painting: Cosmopolitan Concerns and Critical Controversies," in *Archives of American Art Journal,* XXIII (1983), pp. 19–26

6. Lois Marie Fink, "American Renaissance: 1870–1917," in *Academy: The Academic Tradition in American Art* (1975), pp. 79–90. The Society of American Artists was initially founded by Augustus Saint-Gaudens, Wyatt Eaton, Walter Shirlaw, Helena de Kay Gilder, Frederick Dielman, Olin Levi Warner, R. Swain Gifford, and Arthur Quartley.

7. Low to Kenyon Cox, Sept. 19, 1901, Kenyon Cox Papers, Avery Library, Columbia University, New York City; Edwin H. Blashfield, *Mural Painting in America* (1913), pp. 109–121. There were of course exceptions to the architect-artist relationship, particularly in the case of public statuary created by prominent sculptors of the day. In these instances, the sculptor secured the commission and then engaged the architect to design his architectural setting. Examples of this relationship were the *Sherman Monument* (*cf.* no. 66) by Saint-Gaudens, with pedestal designed by Stanford White, and the *Abraham Lincoln* and the *Spencer Trask Memorial* (nos. 22, 23), both by Daniel Chester French, in collaboration with the architect Henry Bacon.

8. These included the Tile Club, Century Club, Lotus Club, and the Tavern Club in New York, and the St. Botolph Club in Boston, Massachusetts.

9. Charles Moore, *Daniel H. Burnham, Architect, Planner of Cities,* I (1921), p. 47; quoted in *The American Renaissance: 1876-1917,* exhibition catalogue, Brooklyn Museum, New York (1979), pp. 12–13, footnote 4

10. Low, "Our Present and Our Future," in *A Painter's Progress,* p. 251

11. Howard Mumford Jones, "The Renaissance and American Origins," in *Ideas in America* (1944), pp. 140–51

12. James Jackson Jarves, *The Art Idea* (1860); Charles Eliot Norton, *List of Principle Books Relating to The Life and Works of Michelangelo* (1879); Jakob Burckhardt, *The Civilization of the Renaissance in Italy* (1878)

13. Neil Harris, "The Gilded Age Reconsidered Once Again," in *Archives of American Art Journal,* XXIII (1983), p. 8

14. Lois Marie Fink, "Evolutionary Theory and Nineteenth Century American Art," in *American Art Review* (Jan. 1978), pp. 75–109

15. For a partial listing of American mural paintings, with geographical locations, up to 1911, see Florence N. Levy, "Mural Painting in the United States," in *American Art Annal,* IX (1911), pp. 12–25

16. Kenyon Cox, "Mural Painting in France and in America," in *Concerning Painting* (1917), pp. 256, 258

17. Blashfield, "The Importance of Decoration," in *Mural Painting in America,* p. 16

18. Trudy Baltz, "Pageantry and Mural Painting: Community Rituals in Allegorical Form," in *Winterthur Portfolio,* XV (Autumn 1980), pp. 211–28

19. Joshua C. Taylor, "America as Symbol," in *America As Art* (1976), pp. 3–34. Taylor noted that America's original symbol, the "Indian Princess," gave way not to a new geographical symbol but to personified virtues, universal ideas; after the revolution (1776) the eagle (incarnation of Zeus) gave way to female personifications.

20. Ibid.

21. Low, "The Mural Painting in the Panthéon and Hôtel De Ville of Paris," in *Scribner's Magazine,* XII (Dec. 1892), pp. 661–77; Jack J. Spector, *The Murals of Eugene Delacroix at Saint-Sulpice* (1967)

22. Low, "National Expression in American Art," in *The International Monthly,* III (March 1901), pp. 239, 241

23. Wilson H. Faude, "Associated Artists and the American Renaissance in the Decorative Arts," in *Winterthur Portfolio 10* (1975), pp. 101–130

24. John La Farge, "Lecture V: Maia, or Illusion," in *Considerations on Painting* (1901), p. 161

25. Harris, *op. cit.,* p. 12

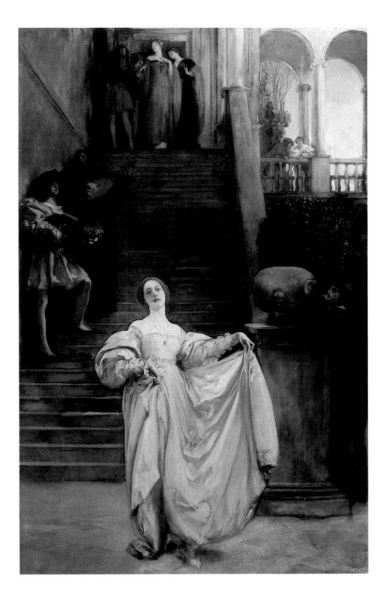

EDWIN AUSTIN ABBEY (1852-1911)

1. A Measure

Oil on canvas, 84¾ × 54¼ in.

Signed and dated (at lower left, on the bottom step):
E. A. Abbey/1904; (on the back): E A Abbey/1904

RECORDED: Arthur Hoeber, "Edwin Austin Abbey," in
The International Studio, XLIV (Oct. 1911), p. v no. 176
illus. // Betty Rivera, "Art: Heroines in Literature," in *Architectural Digest,* LVIX (Jan. 1983), p. 107 illus. in color

While Paris was considered by many American art students during the 1870's and 1880's to be the art center of Europe, London, with its Victorian heritage and time-honored Royal Academy, offered an important alternative. From his adolescence, Abbey had been attracted to English culture. He remained steadfast in his preference, and in 1879 moved to England and resided there permanently until his death. While Abbey, near the end of his life,

would confess that he had been wrong to think London was the only true art center [Letter, Abbey to Will H. Low, May 18, 1909, Low Papers, Albany Institute of History and Art, New York], his penchant for English literary subjects as the basis for his work in illustration, easel painting, and mural decoration was understandable.

This picture illustrates a passage from William Shakespeare's *Much Ado About Nothing*, Act II, Scene I, in which Beatrice says: "The fault will be in the music, cousin, if you be not wooed in good time. If the Prince be too important, tell him there is measure in everything, and so dance out the answer. For, hear me, Hero, wooing, wedding, and repenting is as a Scotch jig, a measure, and a cinque-pace: the first suit is hot and hasty like a Scotch jig and full as fantastical; the wedding, mannerly modest, as a measure, full of state and ancientry; and then comes repentence, and, with his bad legs falls into the cinque-pace faster and faster, till he sink into his grave."

KARL BITTER (1867-1915)

2. Pomona, the Goddess of Abundance

Plaster, 24 in. high

Signed (on the base): KARL BITTER

Executed between 1914 and 1915

RECORDED: James M. Dennis, *Karl Bitter: Architectural Sculptor 1867-1915* (1967), pp. 240 figs. 104 and 105, 241-44, 286-87 footnote 30 // Wayne Craven, *Sculpture in America* (1968), p. 473 // Beatrice Gilman Proske, *Brookgreen Gardens Sculpture* (revised and enlarged ed., 1968), p. 94 // Lewis I. Sharp, *New York City Public Sculpture by 19th-Century American Artists* (1974), p. 53 // Hudson River Museum, Yonkers, New York, *The Sculpture of Isadore Konti* (1974), [n.p.] nos. 64a and 64b // Barbara Gallati, "Carved and Modeled: American Sculpture," in *Arts*, LVII (Oct. 1982), p. 24

EXHIBITED: Hirschl & Adler Galleries, New York, 1982, *Carved and Modeled: American Sculpture 1810-1940*, pp. 74-75 no. 43 illus. in color

EX COLL.: the sculptor, until 1915; to his studio assistant, Karl Gruppe, until 1981

When the publisher Joseph Pulitzer died in 1912, he left a bequest of $50,000.00 "for the erection of a fountain at some suitable place in Central Park, preferably at or near the Plaza entrance at 59th Street, to be as far as possible like those in the Place de la Concorde, Paris, France" [Pulitzer Will, reprinted in Dennis, *op. cit.*, p. 232]. Karl Bitter, a sculptor who was very concerned with creating beautiful public spaces within the city squares of New York, was naturally selected to oversee the project and, indeed, ultimately to create the central figure surmounting the fountain. After months of negotiation between

Bitter, the executors of Pulitzer's estate, and various New York Art Commission members, and with some additional funding from the City, the site between the Plaza Hotel and Fifth Avenue at 58th Street was chosen. Thomas Hastings of the New York architectural firm of Carrère and Hastings was engaged to design the fountain.

Bitter began working on the model for *Pomona* in the fall of 1914 and the following spring he cast it into plaster. Mindful of the angle from which the sculpture was to be viewed, the sculptor specifically designed it to be seen from below. Tragically, on April 9, 1915, while leaving the Metropolitan Opera House, Bitter was hit by an automobile and killed. His studio assistant, Karl Gruppe, then used this plaster to make an enlarged replica, which was somewhat embellished with help from the established sculptor Isadore Konti. The full-size model was cast into bronze and installed atop the Pulitzer Fountain in 1916.

This unique plaster, therefore, is the last work done by Karl Bitter and is the basis for one of the most celebrated statues in New York. Posthumous bronzes taken from it are in the collections of The Century Association, New York, and Brookgreen Gardens, Murrells Inlet, South Carolina.

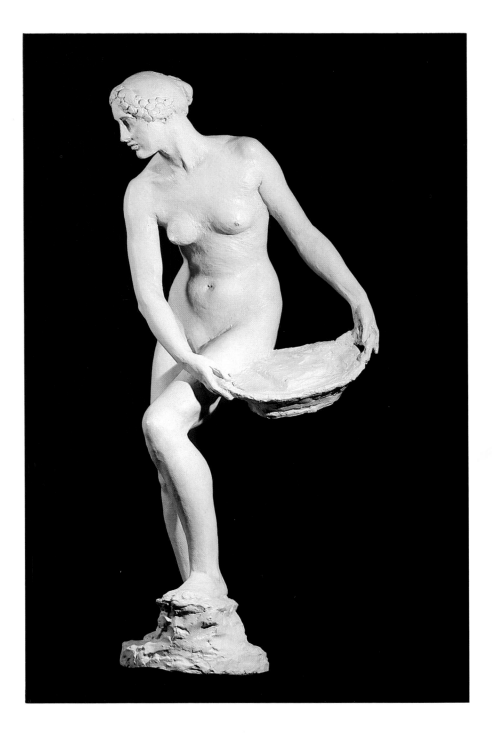

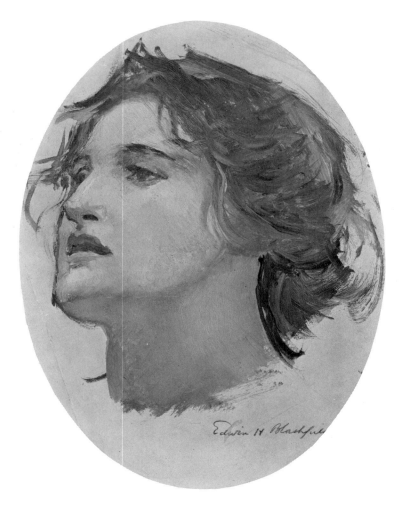

EDWIN HOWLAND BLASHFIELD (1848-1936)

3. Head of a Woman

Oil on cardboard, 8⅞ × 6¹⁵⁄₁₆ in. (oval)

Signed (at lower right): Edwin H Blashfield

Painted about 1890-1910

Often called the "dean of American mural painters," Edwin Blashfield executed murals for such important public buildings of the American Renaissance as the Manufactures and Liberal Arts Building, World's Columbian Exposition, Chicago, Illinois, 1892-93, the Library of Congress, Washington, D.C., 1895-96, and the Minnesota State Capitol Building, St. Paul, 1904, as well as for private residences, including the homes of William K. Vanderbilt, New York, 1896-97, and George W. C. Drexel, Philadelphia, Pennsylvania, 1898. Almost always allegorical in content, these murals generally related to the purpose of the building that contained them. Titles ranged from *Uses of Wealth* (Cleveland Trust Company, Ohio) to *The Graduate* (Great Hall, City University of New York, New York) and *Academia* (American Academy and Institute of Arts and Letters, New York). The present work, quickly but confidently executed, is undoubtedly a preliminary sketch for one of Blashfield's many large-scale murals.

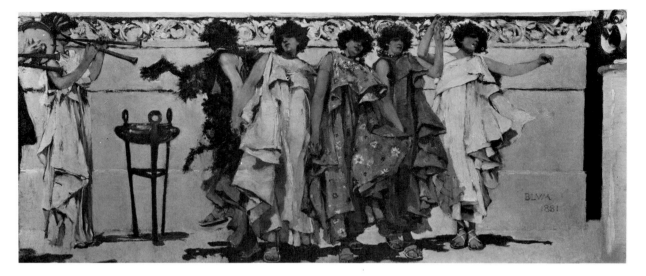

ROBERT FREDERICK BLUM (1857-1903)

4. Dancing to the Flute

Oil on canvas, 9½ × 23½ in.

Signed and dated (at lower right): BLVM/1881

RECORDED: Letter, Bruce Weber, Washington, D.C., to Jane L. Richards, Hirschl & Adler Galleries, New York, Jan. 11, 1978 (ms., Hirschl & Adler archives)

EXHIBITED: Hirschl & Adler Galleries, New York, 1979, *Recent Acquisitions of American Art 1769-1938*, [n.p.] no. 30 illus. in color

EX COLL.: [Hirschl & Adler Galleries, New York, 1977-79]; to private collection

In a letter dated January 11, 1978 [*loc. cit.*], Bruce Weber,, who has just completed his doctoral dissertation at the City University of New York Graduate School on Robert Blum, wrote: "[*Dancing to the Flute*] appears to relate to a series of illustrations Blum prepared for *Scribner's Magazine* (May 1881, Vol. 22, No. 1, pp. 11-21) . . . for the poem *Calpurnia*, by Hjalmar Hjorth Boyesan, who frequently contributed poems to Scribner's. . . . It is also an early example of Blum's interest in Ancient Greek or Roman rites, later characterized by the artist's murals for the Mendelsohn Glee Club, now in the collection of the Brooklyn Museum [New York]."

A photograph (Cincinnati Art Museum, Ohio, archives) of the artist in his studio at The Sherwood Studios, New York, taken around 1881, shows *Dancing to the Flute* on the easel.

This is very possibly the painting exhibited at the Society of American Artists, New York, in 1881, as no. 138, under the title *The Dance*. That work, listed in the accompanying catalogue on p. 11, was for sale at $400.00.

Private collection

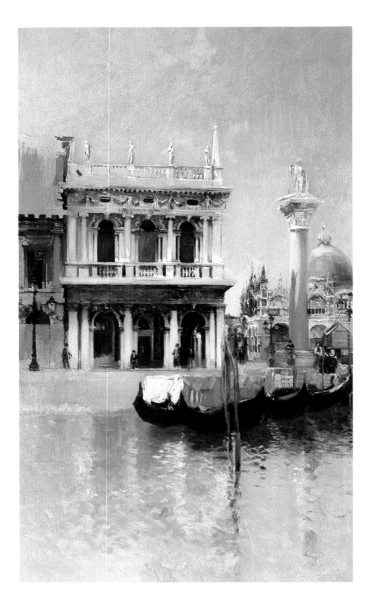

ROBERT FREDERICK BLUM (1857-1903)

5. The Libreria, Venice

Oil on canvas, 28⅞ × 19 in.

Painted between 1886 and 1889

EXHIBITED: Coe Kerr Gallery, New York, and Boston Athenaeum, Massachusetts, 1983, *Americans in Venice: 1879-1913*, pp. 45 no. 27 illus., 89

EX COLL.: the artist; Flora de Stephano; Frank Gessner, Clearwater, Florida; [Coe Kerr Gallery, New York, by 1983]; to private collection, 1983-85

In his essay on Robert Blum, Royal Cortissoz described the artist's personal rapport with Venice, Italy:

> No painter of Venice has surpassed Blum in the fragility of his impressions, in the delicacy of fibre, in their ravishing precision . . . ["Robert Blum," in *Personalities in Art* (1925), p. 411]

By the late 1880's, when Blum painted *The Libreria,* Venice had become an international artists' colony. Painters, watercolorists, architects, and illustrators, in search of the picturesque, flocked to this magical city known for its mysterious light, exotic architecture, and meandering canals. Blum had been coming to Venice since 1880, and, according to Bruce Weber, he depicted the local people of Venice, its workers, and market places, during his initial sojourns. While many artists painted the city, Blum's work was distinguished for its compositional clarity, color, and light. By 1925, when he wrote in praise of Blum, Cortissoz would have been familiar with a vast body of work by artists who had painted this majestic city. In Blum he recognized a painter who surpassed the majority with his personal impressions:

> His Venice is a dreamy pageant, a place of such scenes as only an observer of imagination as well as of skill could have arrested on the canvas [*ibid.,* p. 412].

ROBERT FREDERICK BLUM (1857-1903)

6. A Siesta

Pastel on tan paper, 7½ × 11 in.

Signed with artist's stamp (at upper left): Blum

Executed between 1890 and 1891

RECORDED: Robert Blum, "An Artist in Japan," in *Scribner's Magazine*, XIII (Apr. 1893), p. 412 illus.

EXHIBITED: The Society of the Four Arts, Palm Beach, Florida, 1985, *American Impressionist Drawings*, [n.p.] [n.n.], as *Repose*

EX COLL.: Alfred Corning Clark, New York; to Jane F. Clark, New York, until 1982

In 1884 the Society of Painters in Pastel, New York, exhibited Blum's first picture in a medium that came to express the lyrical beauty and immediacy of his best work. In 1890 he was commissioned to execute drawings to illustrate Sir Edwin Arnold's *Japonica*. From 1890 to 1891 he lived in Japan and visually recorded the diversity of Japanese life with notable candor and sensitivity. *A Siesta* is one of a remarkable series of pastels executed during this sojourn.

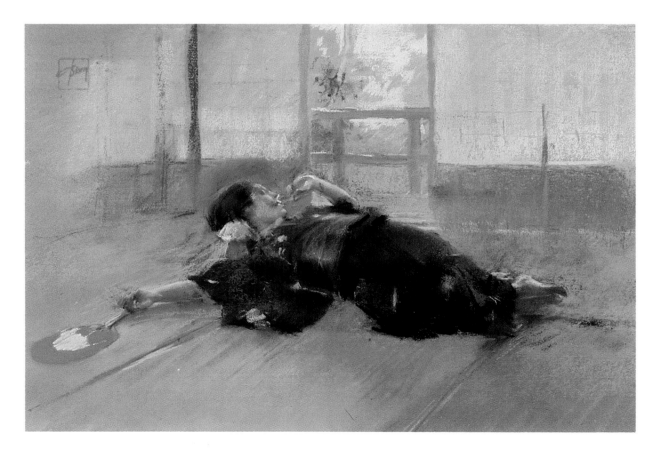

BRYSON BURROUGHS (1869-1934)

7. The Education of Orpheus

Oil on canvas, 31¼ × 53 in.

Signed and dated (at lower left): BRYSON
BURROUGHS/1923

EXHIBITED: Montross Gallery, New York, 1924, *Bryson
Burroughs Paintings and Drawings*, [n.p.] no. 1 // The
Metropolitan Museum of Art, New York, 1935, *Bryson Bur-
roughs Memorial Exhibition*, p. 4 no. 37 illus. // Hirschl &
Adler Galleries, New York, 1984, *The Paintings of Bryson
Burroughs*, p. 22 no. 11 illus. in color

EX COLL.: estate of the artist

As Curator of Paintings at The Metropolitan Museum of Art,
New York, from 1909 until his death, Burroughs fostered
a liberal aesthetic and, in spite of public indifference,
acquired works for the museum by Albert Pinkham Ryder,
Thomas Eakins, and Paul Cézanne. With his own paint-
ing, however, he avoided the controversial innovations of
Ryder and Cézanne, and instead maintained a figurative
style in which allegory and myth were given a contempo-
rary twist. Unlike the high-minded academicism of Ken-
yon Cox and Edwin Blashfield, both contemporaries and
staunch defenders of the classical precepts of the Ameri-
can Renaissance, Burroughs' lively sense of humor was
never undermined by the seriousness of his subject mat-
ter. His pictures were intimate, sometimes whimsical
interpretations of antique themes.

The Education of Orpheus depicts a subject from Greek
mythology: Orpheus, the God of music and poetry, being
taught by the muses to play the lyre. Compositionally,
Burroughs' arrangement of figures parallel to the picture
plane suggests a classical frieze. Conscious of his
sources, he brought to this work a formal strategy that
recalls the work of Puvis de Chavannes and the Italian
Renaissance master Andrea Mantegna. Art historical erudi-
tion, however, is tempered by sensitivity and human
insight.

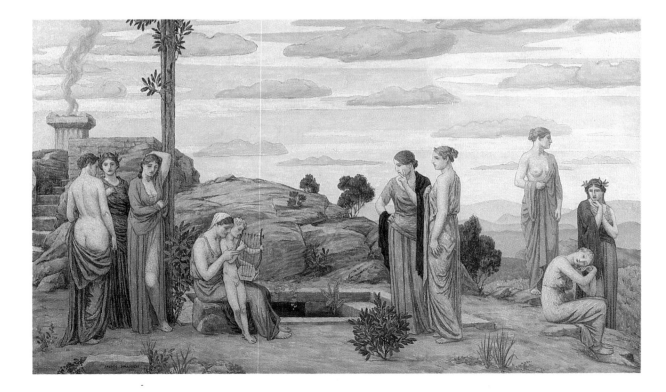

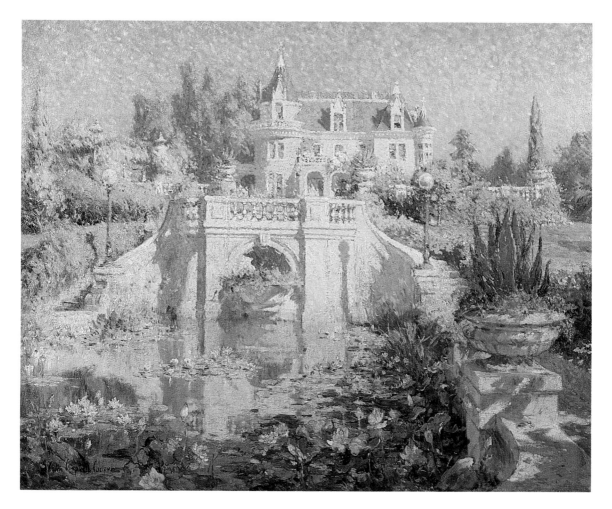

COLIN CAMPBELL COOPER (1856-1937)

8. Kimberly Crest, Redlands, California

Oil on canvas, 29½ × 36½ in.

Signed (at lower left): Colin Campbell Cooper

Painted about 1929

The architecture, both public and domestic, of the American Renaissance referred not only to Greek and Roman models, often interpreted through the Italian Renaissance, but also to a variety of other historical styles. Whether for a mansion on Fifth Avenue or a "villa" in the country, some of the most popular sources of inspiration were the great châteaux along the Loire River in France, built in the sixteenth century under the reign of Francis I.

The turreted house depicted by Colin Campbell Cooper, an American impressionist painter who had studied at the Académie Julian in Paris at the same time as the Americans Willard Metcalf, Robert Reid, Childe Hassam, and Lilla Cabot Perry, recalls such examples of the French Renaissance as Chambord, Chenonceaux, and Azay-le-Rideau. The house shown here was built in 1897 at Redlands, in southern California near San Bernardino, for Mrs. Cornelia Hill, from designs by the Los Angeles architectural firm of Dennis & Farwell. Since this building appears to be unique in the work of this firm, it has been

suggested by Dr. Larry Burgess of the Smiley Public Library in Redlands that Mrs. Hill, who undoubtedly knew the numerous "châteaux" that lined Fifth Avenue, New York, and other leading residential areas in the East, had suggested the style for her new home.

In 1905 the house was purchased by Mr. and Mrs. J. A. Kimberly of the Kimberly and Clark Paper Company, who named the house "Kimberly Crest." The Kimberlys remained in the house until their death, after which their daughter Mrs. Sherk lived there until her own death in 1979. The building and grounds are now run as a non-profit foundation and are open to the public.

Another painting by Cooper, titled *A Garden at Redlands* and dated to about 1929, is probably a view of the gardens at Kimberly Crest [*cf.* The Oakland Museum Art Department, *Impressionism: The California View—Paintings 1890-1930* (1981), p. 82 illus.].

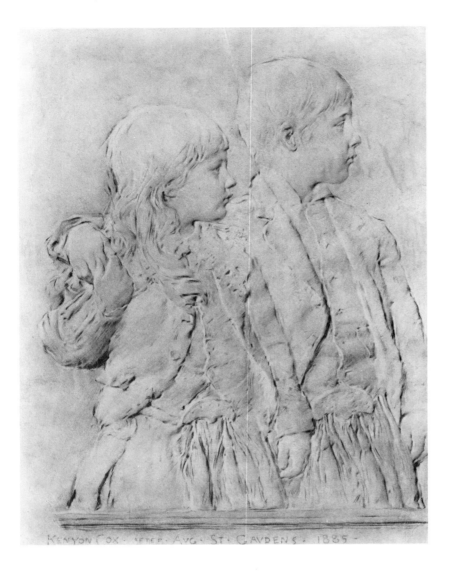

KENYON COX (1856-1919)

9. The Butler Children, drawn after a marble relief by Augustus Saint-Gaudens

Charcoal on paper, 22 × 17 in.

Signed, dated, and inscribed (across the bottom):
KENYON COX · AFTER · AVG · ST · GAVDENS · 1885 ·

RECORDED: "Principal Accessions by Gift, November-December 15," in *The Bulletin of the Metropolitan Museum of Art, New York*, I (Jan. 1906), p. 25 illus.

Perhaps more than any artist of his generation, Kenyon Cox, through his art and writing, promoted precepts of classicism that embodied the American Renaissance. To his mind, the "Classic Spirit" was a disinterested search for perfection, self-control, and continuity, and he staunchly defended academic principles against the radical innovations of modernism. As a teacher he demanded strict rules of draughtsmanship, anatomy, proportion, and perspectival composition, fundamental principles that had earlier provided the basis of his own art education during the 1870's in the Parisian atelier of Jean-Léon Gérôme.

Within this academic context, sculpture was considered an important component. Not only were art students taught to draw from antique plaster casts and marbles, but sculptors, like painters, were expected to familiarize themselves with the history of their medium. In this respect, Augustus Saint-Gaudens was held in high esteem by Cox (as well as his professional colleagues) as a contemporary incarnation of the "Classic Spirit."

Executed in charcoal to simulate Saint-Gaudens' marble relief of *Charles Stewart and Lawrence Smith Butler* (The Metropolitan Museum of Art, New York), Cox's drawing is both a personal tribute to the sculptor and a symbol of the reciprocity that united artistic disciplines during this collaborative period of American art.

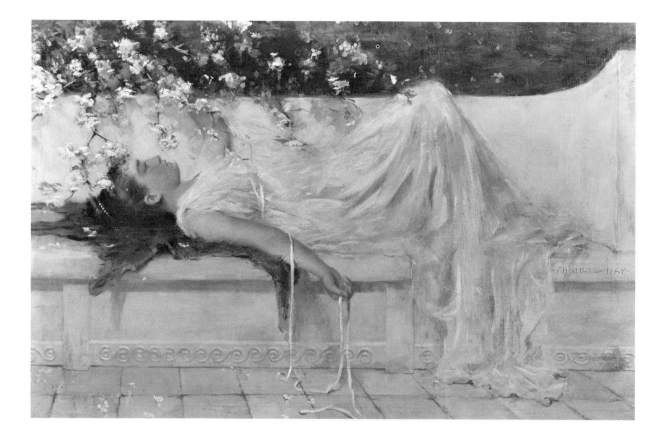

FRANCIS DAY (1863-1942)

10. Reverie

Oil on wood panel, 12 × 18⅛ in.

Signed (at lower right): -FRANCIS-DAY-

EX COLL.: Amzi Lorenzo Barber and his descendents, until 1981; to [Hirschl & Adler Galleries, New York]; to private collection, 1981-85

Painted about 1905

Francis Day studied at the Art Students League, New York, under James Carroll Beckwith before he left for Paris and enrolled at the Ecole des Beaux-Arts. He was elected to the Society of American Artists in 1891, and later became an associate member of the National Academy of Design, New York, after the Society merged with it in 1906. Spending the latter part of his life with his family in Lanesborough, Massachusetts, Day painted genre scenes, portraits, and landscapes.

A classical genre picture, *Reverie* recalls similar paintings by F. D. Millet (no. 55), Francis C. Jones (no. 34), and Will H. Low (no. 44). Modeled with a female figure in antique drapery lying horizontally on a marble bench decorated at its base with classical motives, *Reverie* evokes the past through allusion.

NICOLA D'ASCENZO (1871-1954)

11. "West Window" for the Metropolitan Memorial Methodist Episcopal Church, Washington, D.C.

Watercolor and gold paint on paper, 25¾ × 12⅝ in.

Inscribed on the original mat: THORAFL M. FUNDT. Architect in charge; Metropolitan Memorial Methodist Episcopal Church/Washington, D.C.; THE D'ASCENZO STUDIOS, Phila.

Executed in 1931

By the turn-of-the-century, stained glass had become an integral part of architectural and interior design. Elaborate commissions for fixtures, windows, and ornamentation for churches, hotels, schools, and private residences gave rise to a network of commercial studios whose mass production matched the demand of a burgeoning market.

Nicola D'Ascenzo was born in Italy, and came to America in 1882. He trained at the Pennsylvania Academy of the Fine Arts and the Industrial Art School, both in Philadelphia. By 1896 he formed D'Ascenzo Studios, on Ludlow Street, Philadelphia, a large and very successful workshop whose stained glass commissions for public and private clients were scattered throughout the United States and Mexico.

Collaborating with the Philadelphia architectural firm Fundt and Wenner, D'Ascenzo executed this rendering for the large *West Window* of the Metropolitan Memorial Methodist Episcopal Church, Washington, D.C. Colored renderings were executed to give architects and would-be clients a conceptual idea of the finished program. For this *West Window*, D'Ascenzo designed a series of elaborate lancet windows with Christ in the center flanked by two male saints, who, in turn, are flanked by four female saints, personifications of "Faith," "Hope," "Love," and "Justice."

For this same project D'Ascenzo Studios designed and executed a narthex screen, seventy-two door panels, and oversaw the transfer of stained glass from an old Washington church to the new clerestory windows of the Methodist Episcopal Church. Funds for the program were donated, in part, by Mrs. W. A. Hanney, of Washington, D.C.

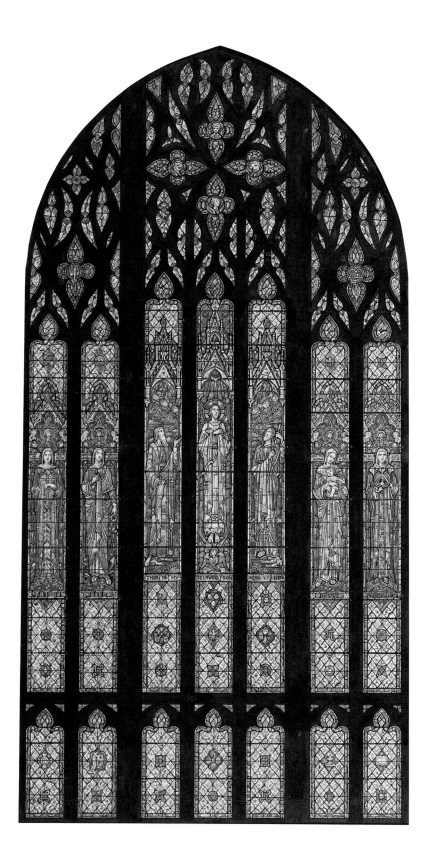

ARTHUR B. DAVIES (1862-1928)

12. Mountain of Inheritance

Oil on canvas, 18 × 40¼ in.

Signed (at lower left): A.B. DAVIES

Painted between 1911 and 1912

RECORDED: Royal Cortissoz, *Arthur B. Davies* (1931), p. 29, as in the collection of H. H. Benedict

EX COLL.: [Ferargil Galleries, New York]; H. H. Benedict, New York; by descent to Mary J. Graham (Mrs. Robert L. Graham, Jr.)

A.B. Davies' relationship to the American Renaissance is problematic. Though he maintained a figurative focus in his work, straight-forward allegory was superseded by personal metaphor and poetic imagination. Like Bryson Burroughs, he redefined a "classical" sensibility, giving it broader interpretation and personal expression. For this reason Davies stands outside the mainstream of "academic" art as a visionary artist in much the same way Albert Pinkham Ryder, Ralph Blakelock, and Louis M. Eilshemius stood outside the prevailing artistic conventions of their time.

Throughout his life, Davies remained receptive to new ideas. His involvement with the Armory Show of 1913 brought his own work, especially his figure studies, to the threshold of abstraction; he embraced experimentation and change. *Mountain of Inheritance* is fundamentally a figurative picture, traditional in the sense that few liberties are taken with anatomy, proportion, or perspective. Its content, however, is strange and enigmatic. Unlike others of his generation—painters who maintained traditional narrative subjects as the basis of their work—Davies never felt inclined to be didactic or anecdotal. Using the formal vocabulary of nineteenth century academic art, he sought to endow his own paintings with psychological depth and emotional intensity.

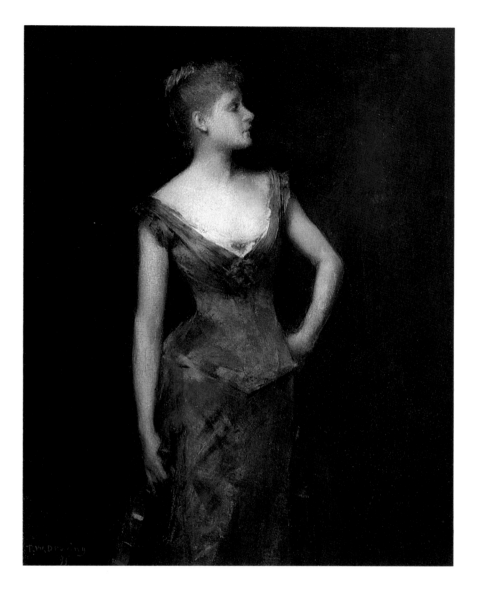

THOMAS WILMER DEWING (1851-1938)

13. Woman with Violin

Oil on wood panel, 10 × 8 in.

Signed and dated (at lower left): T.W. Dewing/91

EXHIBITED: Santa Barbara Museum of Art, California, 1973, *American Paintings, Watercolors and Drawings from the Collection of Jo Ann and Julian Ganz, Jr.*, [n.p.] no. 26 illus. // National Gallery of Art, Washington, D.C., Amon Carter Museum, Fort Worth, Texas, and Los Angeles County Museum of Art, California, 1981-82, *An American Perspective: Nineteenth-Century Art from the Collection of Jo Ann & Julian Ganz, Jr.*, pp. 43, 71 fig. 65, 72, 75, 127 illus.

EX COLL.: William Cheney, Hartford, Connecticut; Frank Platt (by inheritance); estate of Charles A. Platt; to [E. and A. Milch, Inc. New York]; to Jo Ann and Julian Ganz, Jr., Los Angeles, California, 1972-84

Music was a subject of great importance to artists of the American Renaissance, and to Dewing, in particular, who enjoyed a certain proficiency with the violin. Musical instruments were frequently included in compositions of the time, whether classical as in Robert Blum's *Dancing to the Flute* (no. 4) and Francis Coates Jones' *Lady and Lyre* (no. 36), or contemporary as in *Woman with Violin*, and became part of the feminine iconography. As in many of Dewing's paintings, the violin here does not have any specific symbolic or allegorical imagery; instead, it suggests the cultural refinement and grace of the sitter, qualities favored by artists of this period.

The painting retains its original lattice-work frame designed by Stanford White (1853-1906) of the New York architectural firm of McKim, Mead, and White.

THOMAS WILMER DEWING (1851-1938)

14. Lady in Green

Oil on canvas, 21⅜ × 16⅛ in.

Signed (at lower right): TW Dewing

Painted about 1910-15

RECORDED: Letter, Susan Hobbs, Visiting Scholar, National Museum of American Art, Washington, D.C., to Stuart P. Feld, Hirschl & Adler Galleries, New York, June 25, 1984 (ms., Hirschl & Adler archives)

EXHIBITED: Wadsworth Atheneum, Hartford, Connecticut, 1936, *Paintings in Hartford Collections*, [n.p.] no. 41, as *Woman in Green*, lent by Mr. and Mrs. Charles F. T. Seaverns // Durlacher Bros., New York, 1963, *A Loan Exhibition, Thomas Dewing 1851-1938*, [n.p.] no. 18, as about 1909, lent by Nelson C. White // Yale University Art Gallery, New Haven, Connecticut, 1968, *American Art from Alumni Collections*, [n.p.] no. 130 illus., typewritten checklist (ms., Frick Art Reference Library, New York), pp. 182-83, as about 1909, lent by Nelson C. White // Wildenstein & Co., New York, and Philadelphia Museum of Art, Pennsylvania, 1971, *From Realism to Symbolism: Whistler and His World*, pp. 71-72 no. 65 pl. 58.

EX COLL.: [Montross Gallery, New York]; Mr. and Mrs. Charles F. T. Seaverns, Hartford, Connecticut, by 1936; to Mrs. Charles F. T. Seaverns, Hartford, Connecticut; to Mr. Appleton Seaverns, Hartford, Connecticut, by 1956; to [sale, Parke-Bernet Galleries, New York, Dec. 6, 1956, p. 34 no. 172]; Mr. Nelson C. White, Waterford, Connecticut, by 1963-82; to private collection, until 1983

The subjects of Dewing's mature work are usually one or more women situated in a simply, yet artfully, arranged interior. These elegant ladies are often dressed in long flowing gowns or robes and are rarely occupied in any activity. The models are purposefully posed to create an impression of the refinement of the sitter, her environment, and ultimately the artist who designed the subtle color harmonies and delicate composition.

According to Susan Hobbs, who is currently compiling a catalogue raisonné of Dewing's work, *Lady in Green* was probably executed between 1910 and 1915 and is one of a series of paintings in profile done by the artist of the same high cheek-boned model, who has as yet not been conclusively identified. Two related works are *Lady in White, No. 1* and *Lady in White, No. 2*, both in the collection of the National Museum of American Art, Washington, D.C.

This picture also retains its original lattice-work frame designed by Stanford White (1853-1906) of the New York architectural firm of McKim, Mead, and White.

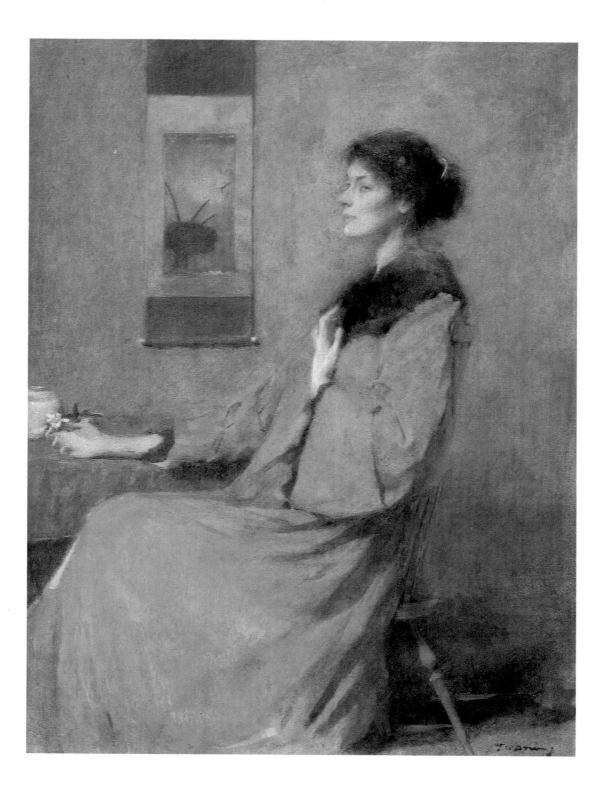

THOMAS WILMER DEWING (1851-1938)

15. Seated Woman

Pastel on brown paper, 14¼ × 11 in. (sight size)

Signed and numbered (at lower right): T.W. Dewing/105

Executed about 1915-20

RECORDED: Letter, Susan Hobbs, Visiting Scholar, National Museum of American Art, Washington, D.C., to Stuart P. Feld, Hirschl & Adler Galleries, New York, June 25, 1984 (ms., Hirschl & Adler archives)

EX COLL.: [Victor Spark, New York, until 1962]; to private collection, Michigan, until 1981

THOMAS WILMER DEWING (1851-1938)

16. Standing Woman

Pastel on brown paper, 14 × 10¹³⁄₁₆ in. (sight size)

Signed and numbered (at lower right): TWDewing/202

Executed about 1918-25

RECORDED: Memorandum, Thomas W. Dewing to Macbeth Gallery, New York, June 8, 1926 (Macbeth Gallery Papers, Archives of American Art, Roll no. NMc42, Frame 610), as no. 202 // Letter, Robert W. Macbeth, Macbeth Gallery, New York, to Thomas W. Dewing, Oct. 1, 1928 (Macbeth Gallery Papers, Archives of American Art, Roll no. NMc42, Frame 616), as no. 202 // Letter, Susan Hobbs, Visiting Scholar, National Museum of American Art, Washington, D.C., to Stuart P. Feld, Hirschl & Adler Galleries, New York, June 25, 1984 (ms., Hirschl & Adler archives)

EX COLL.: the artist; to [Macbeth Gallery, New York, in 1928]

Susan Hobbs has noted [*loc. cit.*] that during the years 1918 to 1925 Dewing worked exclusively in pastel. It appears from Macbeth Gallery, New York, records that there was a high demand for them, which culminated in an exhibition of his pastels in 1924 at The Corcoran Gallery of Art, Washington, D.C. After about 1925-29, Dewing's production dropped off sharply, making his work in pastel his final artistic phase.

Due to the more detailed handling of the medium, Hobbs considers *Seated Woman* to be the earlier of the two works.

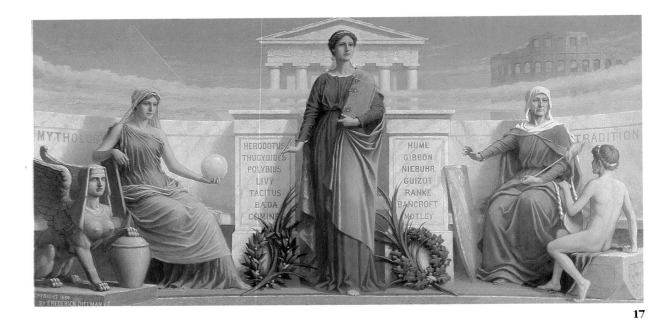

17

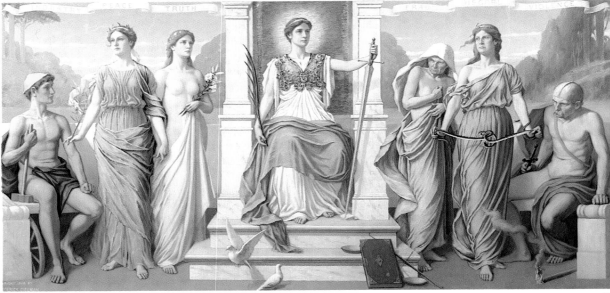

18

FREDERICK DIELMAN (1847-1935)

17. History

Oil on canvas, 44 × 90¼ in.

Signed, dated, and inscribed (at lower left):
COPYRIGHT 1896/BY FREDERICK DIELMAN

RECORDED: cf. William A. Coffin, "The Decorations in the New Congressional Library," in *Century Magazine*, CIII (1897), pp. 694-711, 710 illus. // cf. Pauline King, *American Mural Painting* (1902), pp. 190, 192 illus. // cf. "Dielman, 87, Dean of Painters, Dies," in *The New York Times*, Aug. 16, 1935 // cf. "Dielman Dies; Artist Dean of Academicians," in the New York *Herald Tribune*, Aug. 16, 1935 (clipping file, Art and Architecture Division, New York Public Library, New York)

EXHIBITED: Central Pavilion, The Art Palace, St. Louis, Missouri, 1904, *Universal Exposition*, p. 41 no. 943

EX COLL.: private collection, Stanfordville, New York, until 1983

FREDERICK DIELMAN (1847-1935)

18. Law

Oil on canvas, 44 × 90¼ in.

Signed, dated, and inscribed (at lower left):
COPYRIGHT 1896 BY/FREDERICK DIELMAN; (on the back): FREDERICK DIELMAN 41 WEST 10th ST NEW YORK CITY—

RECORDED: cf. Pauline King, *American Mural Painting* (1902), pp. 190, 191 illus. // cf. "Dielman, 87, Dean of Painters, Dies," in *The New York Times*, Aug. 16, 1935 // cf. "Dielman Dies; Artist Dean of Academicians," in the New York *Herald Tribune*, Aug. 16, 1935 (clipping file, Art and Architecture Division, New York Public Library, New York)

EXHIBITED: Central Pavilion, The Art Palace, St. Louis, Missouri, 1904, *Universal Exposition*, p. 41 no. 942

EX COLL.: private collection, Stanfordville, New York, until 1983

Born in Germany, Frederick Dielman emigrated to America with his family and settled in Baltimore, Maryland. After working for several years as a topographical engineer, he returned to Germany to attend the Royal Academy in Munich. By the mid-1870's he had returned to the United States.

Begun two years after the 1893 World's Columbian Exposition, Chicago, Illinois, the new Library of Congress, Washington, D.C., was an ambitious collaborative undertaking. For this project, which brought together some nineteen painters (to create 112 murals), twenty-two sculptors, and seven ornamental artists, Dielman was commissioned to design and execute two mosaics for the House of Representatives Reading Room. *History* and *Law* are his original designs from which the mosaics were executed.

Monumental paintings in their own right, these panels represent didactic allegorical painting as it was practiced during the American Renaissance. Modeled as personifications, figures symbolize general principles or abstract concepts and bear attributes to identify them.

In *History*, the central figure of the same name is symbolized by her pen and book. To either side of her are "Tradition," identified by her old age, her staff and shield, and "Mythology," who balances in either hand a sphere and stylus and is accompanied by a chimera who guards the contents of an earthenware jar. The names of ancient and contemporary historians are inscribed on two classical plinths to either side of "History." From the background, shrouded in diaphanous mist, emerges the Great Egyptian Pyramid of Cheops, the Greek Parthenon, and the Roman Colosseum, symbolic reminders that the history of mankind's achievements are recorded for posterity in its architectural monuments.

In the companion panel, *Law*, each personification is identified by labels as well as by attributes. "Law," triumphantly enthroned, holds in her left hand the sword of justice and in her right, the palm of peace. On the step in front of her, the written law, symbolized by the closed book, lies next to the scales of justice, and two doves, harbingers of peace and tranquility, flutter to the left. To the right of "Law," Dielman depicted the forces of evil that breed in the absence of law: "Fraud," evasive and unpredictable, "Discord," deranged and viperous, and "Violence," in the guise of a Roman soldier. To the left of "Law" are "Truth," unclothed and holding a lily to symbolize her purity, "Peace," crowned with laurel and bearing a branch from the tree of knowledge, and "Industry," seated with mallet and wheel, youthful and confident. Balanced and symmetrical, this tableau is enacted before a dreamy landscape reminiscent of the work of Puvis de Chavannes.

FREDERICK DIELMAN (1847-1935)

19. Personification of "Peace"

Watercolor and gouache on paper, 14 × 12 in.

Signed and dated (at upper right): Frederick Dielman—
./1902

EXHIBITED: Hirschl & Adler Galleries, New York, 1976,
100 American Drawings and Watercolors from 200 Years,
[n.p.] no. 28 // Whitney Museum of American Art, New
York, The St. Louis Art Museum, Missouri, Seattle Art
Museum, Washington, and Oakland Art Museum, Califor-
nia, 1977-78, *Turn-of-the-Century America: Paintings,
Graphics, Photographs, 1890-1910*, pp. 20 fig. 7, 184, lent
by Hirschl & Adler Galleries, New York // Hirschl &
Adler Galleries, New York, 1979, *American Drawings and
Watercolors*, [n.p.] no. 29 // National Gallery of Art,
Washington, D.C., Amon Carter Museum, Fort Worth,
Texas, and Los Angeles County Museum of Art, California,
1981-82, *An American Perspective: Nineteenth-Century
Art from the Collection of Jo Ann & Julian Ganz, Jr.*, pp. 75,
78 fig. 71, 127 illus., 128

EX COLL.: [Hirschl & Adler Galleries, New York, 1976-79];
to Jo Ann and Julian Ganz, Jr., Los Angeles, California,
1979-82

Dielman based this three-quarter profile head on the head
of "Peace," personified by an olive wreath, in his mosaic/

mural entitled *Law* (no. 18) for the House of Representa-
tives Reading Room, Library of Congress, Washington,
D.C. A variation of "Peace" was later used for the three-
quarter profile of "Moderation" in *The Editorial Function*,
one of seven mural paintings (destroyed) that Dielman
executed for the business office of the new *Evening Star*
building in Washington, D.C. *Personification of "Peace"*
may have commemorated the unveiling of the *Evening
Star* murals in 1902

opposite:

THOMAS EAKINS (1844-1916)

20. An Arcadian

Oil on canvas, 14 × 18 in.

Inscribed (by Mrs. Eakins, at lower right): Eakins

Painted about 1883

RECORDED: Henri Gabriel Marceau, "Catalogue of the
Works of Thomas Eakins," in *The Pennsylvania Museum
Bulletin*, XXV (March 1930), p. 20 no. 44, as *Landscape with
a Seated Female Figure* // Lloyd Goodrich, *Thomas
Eakins* (1933), p. 177 no. 200 // Roland McKinney, *Thomas
Eakins* (1942), p. 106 illus. // *Art Digest* (June 1944), p. 7

illus. // Fairfield Porter, *Thomas Eakins* (1959), pl. 34 //
Gordon Hendricks, *The Life and Work of Thomas Eakins*
(1974), pp. 150-51, 154 fig. 131 // Lloyd Goodrich, *Thomas
Eakins*, I (1982), pp. 230, 232 colorpl. 103, 233, 251 //
Elizabeth Johns, *Thomas Eakins, The Heroism of Modern
Life* (1983), p. 129 footnote 22

EXHIBITED: Babcock Art Galleries, New York, 1930-31,
Thomas Eakins, no. 5 // Babcock Art Galleries, New York,
1939, *Thomas Eakins*, no. 32 // M. Knoedler & Company,
New York, 1944, *A Loan Exhibition of the Works of Thomas
Eakins, 1844-1916, Commemorating the Centennial of
his Birth*, p. 13 no. 35, [n.p.] no. 35 illus. // Carnegie Institute,
Pittsburgh, Pennsylvania, 1945, *Thomas Eakins Centen-
nial Exhibition*, no. 12 illus. // American Academy of Arts
and Letters, New York, 1958, *Thomas Eakins*, no. 47 //
National Gallery of Art, Washington, D.C., The Art Institute
of Chicago, Illinois, and the Philadelphia Museum of Art,
Pennsylvania, *Thomas Eakins, A Retrospective Exhibition*,
p. 78 no. 46 illus. // Whitney Museum of American Art,
New York, 1970, *Thomas Eakins Retrospective Exhibition*,
p. 70 no. 42 // National Collection of Fine Arts, Smith-
sonian Institution, Washington, D.C., 1975, *Academy, The
Academic Tradition in American Art*, p. 208 no. 105
illus. // Brandywine River Museum, Chadds Ford, Pennsyl-
vania, 1980, *Eakins at Avondale*, p. 36 no. 2, front cover
illus. in color

EX COLL.: estate of the artist; to Mrs. Thomas Eakins,
Philadelphia, Pennsylvania; to Mr. Lloyd Goodrich

According to Lloyd Goodrich, who is preparing the cata-
logue raisonné of the work of Thomas Eakins, in which
this picture will be included, *An Arcadian* is "one of
Eakins' few Arcadian subjects, painted at the farm of his
sister and brother-in-law, Frances Eakins Crowell and
William J. Crowell, at Avondale, Pennsylvania." The young
woman who "wears a Greek garment, a double chiton"
was the same model as the one "for the nude woman in the
oil *Arcadia,* now in the Metropolitan Museum of Art
[New York]." Goodrich further noted that: "The model was
also probably the right-hand figure in Eakins' photo-
graph of two women in Greek costumes posing indoors
with a cast of his sculpture relief *Arcadia* (Gordon
Hendricks, *The Photographs of Thomas Eakins,* 1972,
nos. 62 and 63). An oil study of the figure in *An Arcadian* is
in the Hirshhorn Museum and Sculpture Garden [Wash-
ington, D.C.]" [Letter, Lloyd Goodrich to Susan E. Menconi,
Hirschl & Adler Galleries, New York, Feb. 7, 1985 (ms.,
Hirschl & Adler archives)].

Collection of Lloyd Goodrich

DANIEL CHESTER FRENCH (1850-1931)

21. Wisdom

Plaster, 58 in. high

Executed between 1898 and 1900

RECORDED: *cf.* Julie C. Gauthier, *The Minnesota Capitol Official Guide and History* (1907, revised ed. 1939), p. 14: "[Wisdom] is perhaps the most beautiful of the six statues in its poise and its expression of severity tempered with kindliness." // *cf.* Neil B. Thompson, *Minnesota's State Capitol: The Art and Politics of a Public Building* (1974), pp. 37-38 // *cf.* Rena Neumann Coen, *Painting and Sculpture in Minnesota, 1820-1914* (1976), p. 94

EX COLL.: St. Paul Institute of Arts and Sciences, Minnesota, until about 1968-69; to the Minnesota Museum of Art, St. Paul, until about 1975-76; to private collection, St. Paul, until 1982

In 1898 Daniel Chester French was commissioned by the prominent St. Paul, Minnesota, architect Cass Gilbert (1859-1931) to create sculptures for the facade of Gilbert's new Minnesota State Capitol Building in St. Paul. French's sculptural program included six allegorical figures representing the civic and personal virtues of *Truth*, *Bounty*, *Wisdom*, *Prudence*, *Integrity*, and *Courage*, to be placed above the second-story arcade, and beneath his gilded quadriga, or chariot group, entitled *Progress of the State*.

French prepared the working models for the six allegorical figures in his New York studio and completed them in 1900. The plasters, this *Wisdom* among them, were then sent off to Purdy and Hutcheson, St. Paul stone carvers, to be enlarged in marble to approximately twice their size for the Capitol Building facade, where *Wisdom* would be installed first from the left.

One of the great classically-inspired buildings of the American Renaissance, the Minnesota State Capitol also contains a number of works by other major artists of the period, including two murals in the Senate Chamber by Edwin Blashfield, four allegorical murals by John La Farge in the Supreme Court Chamber, a lunette by Kenyon Cox over the staircase leading to the Supreme Court Chamber, and two paintings in the Governor's Reception Room by Francis Davis Millet.

In addition to *Wisdom*, only French's plaster model for *Truth* (The Art Institute of Chicago, Illinois) is known to have survived.

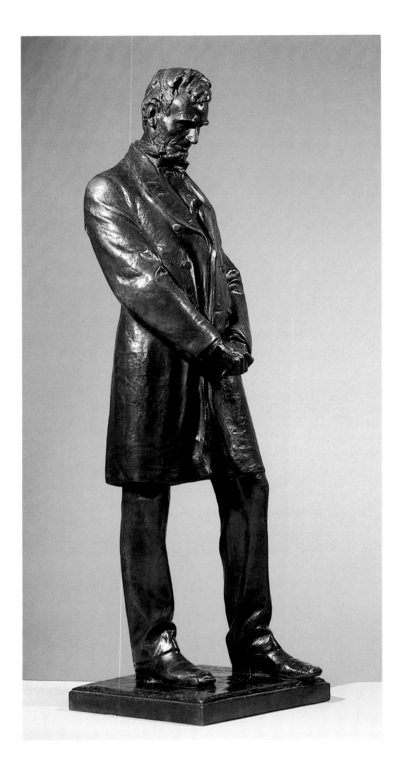

DANIEL CHESTER FRENCH (1850-1931)

22. Abraham Lincoln

Bronze, medium brown patina, 38½ in. high

Signed, dated, and inscribed (on the base): ©Daniel Chester French Sc/1912; inscribed (on the base): ORIGINAL MODEL FOR THE STATUE ERECTED IN LINCOLN/NEBRASKA

Founder's mark (on the base): CAST BY ROMAN BRONZE WORKS N-Y-

RECORDED: *cf.* Michael Richman, *Daniel Chester French: An American Sculptor* (1976), pp. 123, 124 no. 5 plaster illus., 126-27, 128 no. 10 bronze illus., 129 no. 10 // *cf.* Whitney Museum of American Art, New York, *200 Years of American Sculpture* (1976), pp. 62, 63 fig. 91, 340 no. 74 // *cf.* The Brooklyn Museum, New York, *The American Renaissance 1876-1917* (1979), pp. 176, 226 no. 242

EXHIBITED: Hirschl & Adler Galleries, New York, 1982, *Carved and Modeled: American Sculpture 1810-1940*, pp. 56-57 no. 28 illus. in color // Adams Davidson Galleries, Washington, D.C., 1984, *Marble and Bronze: 100 Years of American Sculpture 1840-1940*, p. 21 no. 16 illus. in color

EX COLL.: the artist; to [Grand Central Gallery, New York, Oct. 1924]; to Milford Stern, Detroit, Michigan; to his daughter, until 1980

In 1909, on the one-hundredth anniversary of Abraham Lincoln's birth, Daniel Chester French was commissioned by the Lincoln Centennial Memorial Association of Nebraska to create a monument to the sixteenth President of the United States for the capital city of Lincoln. He engaged the architect Henry Bacon (1866-1924) to design the pedestal and architectural setting for his proposed nine-foot monument. French completed this working model in January 1911; it was unanimously approved by the commissioning board and was then used by the sculptor as the basis for the full-scale statue.

The Memorial Association ran out of funds towards the end of the project, and it was agreed that in lieu of final payment the sculptor would be allowed to have bronzes cast from the original working model. Twelve or more of these are recorded as being made in the years after the monument was officially dedicated in 1912. Of these bronzes, Michael Richman wrote [*op. cit.*, p. 126]: "Unquestionably the best of all the bronze multiples that French produced during his career were those from the working model of the standing *Lincoln.*"

According to Richman, this bronze is recorded in French's account books for October 1924. It was made for the Association of Painters, Sculptors, and Laymen, and was sold or distributed through Grand Central Gallery, New York, to Milford Stern.

Other castings of this working model are in the collections of the Fogg Art Museum, Cambridge, Massachusetts, the Whitney Museum of American Art, New York, The Newark Museum, New Jersey, the University of Nebraska Art Galleries, Lincoln, The Union League, Philadelphia, Pennsylvania, the Stockbridge Plain School, Massachusetts, Ball State Art Gallery, Muncie, Indiana, the Wadsworth Atheneum, Hartford, Connecticut, and Chesterwood, Stockbridge, Massachusetts. Plaster models are in the collections of the University of Nebraska Art Galleries, Lincoln, and The New-York Historical Society, New York.

DANIEL CHESTER FRENCH (1850-1931)

23. Spirit of Life

Bronze, medium brown patina with traces of verdigris, 49¼ in. high

Signed and dated (on the base): D.C. French/May 1914

Founder's mark (on the base): ROMAN BRONZE WORKS N.Y.

RECORDED: *cf.* Michael Richman, *Daniel Chester French: An American Sculptor* (1976), pp. 133-34, 136 no. 9 illus., 137-38, 140 no. 9

Four years after the death of Spencer Trask (1844-1909), a prominent New York businessman, Daniel Chester French was commissioned to create a memorial to him at Trask's longtime summer residence of Saratoga Springs, New York. French worked on the project in collaboration with the architect Henry Bacon (1866-1924); an architectural fountain setting, with a central allegorical figure, was devised, and French began to work up small maquettes in 1913 for what ultimately would become the central *Spirit of Life* figure in the *Spencer Trask Memorial.* He completed this working model in 1914, and in the subsequent year used it as the basis for the full-scale model, which was cast into bronze and installed in Congress Park, Saratoga Springs, New York, in 1915.

Eight bronzes of this working model are recorded as having been cast in the years between 1915 and 1931. The first, of 1915, is now in the collection of the Indianapolis Museum of Art, Indiana, and the second, of 1922, is at Chesterwood, French's former summer home and studio in Stockbridge, Massachusetts. Of the six others, three, in addition to the present example, have been located and are in The Newark Museum, New Jersey, the Wilson Library, University of North Carolina, Chapel Hill, and a park in Brattleboro, Vermont.

According to Michael Richman, Editor of The Daniel Chester French Papers, National Trust for Historic Preservation, Washington, D.C., two of the eight bronzes of the *Spirit of Life* were cast by Roman Bronze Works, New York, as recorded in French's account books. One of these was delivered to the sculptor in July 1924 and the other, in September 1926.

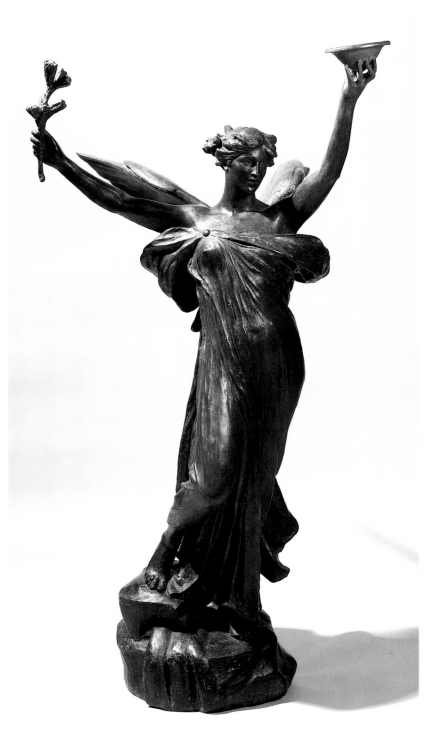

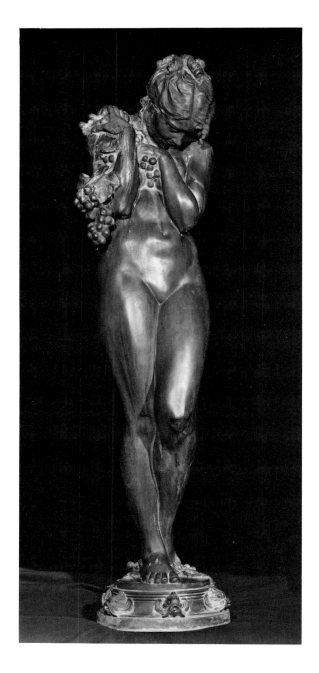

HARRIET WHITNEY FRISHMUTH (1880-1980)

24. Sweet Grapes

Bronze, verdigris patina, 55½ in. high

Signed, dated, and inscribed (on the base): HARRIET · W · FRISHMUTH ©1928

Founder's mark (on the base): GORHAM CO. FOUNDERS

Model executed in 1924

RECORDED: *cf.* Charles N. Aronson, *Sculptured Hyacinths* (1973), pp. 132, 133 illus., 134, 135 illus., 209

In an interview reprinted in Charles Aronson's *Sculptured Hyacinths* (1973), pp. 134-35, Frishmuth commented about the subject:

…*Sweet Grapes* has turned out very well. I made a small size [19½ in. high] first [in 1922], … and then the large size two years later. I sent the large *Sweet Grapes* to the Grand Central Art Gallery Exhibition in 1925, and I got the Irving T. Bush Memorial Prize of a thousand dollars…

In the same interview, Ruth Talcott, Frishmuth's business manager, noted: "There are four of the large *Sweet Grapes* and that edition has been closed now for some years."

The sculpture is piped as a fountain.

WALTER GRANVILLE-SMITH (1870-1938)

25. Coil of Justice

Oil on canvas, 24½ × 18 in.

Signed (at lower left): WGranville-Smith

Painted about 1890-95

Walter Granville-Smith was born in South Granville, New York, and received his early training at the Art Students League, New York, under Willard Metcalf and James Carroll Beckwith. He attended Princeton University, New Jersey, and upon graduation worked in an architectural firm in Newark, New Jersey. He also did illustrations for such magazines as *Harper's* and *The Century Magazine*. In 1890 he began exhibiting paintings at the National Academy of Design, New York, and, in 1897, went to Europe to continue his studies.

Coil of Justice probably dates from the period 1890-95 when the artist was living in Newark and before he devoted himself primarily to landscape painting. The work appears to be a study for a presently unlocated mural.

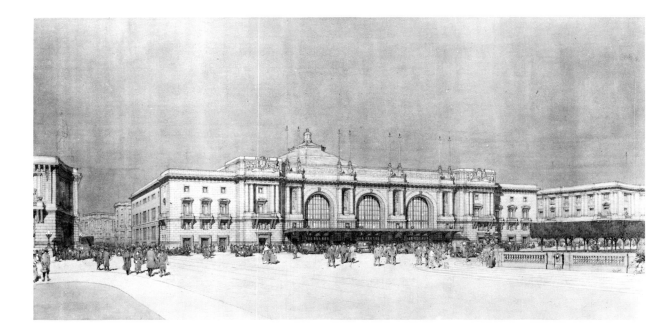

JULES GUERIN (1866-1946)

26. Civic Auditorium, San Francisco, California

Watercolor, pencil, and ink on paper, 33¾ × 69⅜ in.

Signed (at lower right): Jules Guerin

Executed about 1914

EXHIBITED: Farish Gallery, Rice University, Houston, Texas, 1983, *Jules Guerin: Master Delineator* p. 16, no. 21, as *San Francisco, Civic Auditorium from Civic Center Mall* // North Point Gallery, San Francisco, California, 1984, *Works of Art in the Exhibition of California Painters at the North Point Gallery*, [n.p.] no. 23

EX COLL.: Charles Osborn and David Woods, San Francisco, and Nevada City, California, until about 1966; to Dr. Joseph Baird, San Francisco, California, until 1984

Like others of his generation, Jules Guerin received extensive art training that enabled him to practice such diverse disciplines as easel painting, mural decoration, illustration, stage design, and architectural rendering. Born in St. Louis, Missouri, he was given his first art instruction in Chicago, Illinois, where he lived from 1880 until 1896. Shortly thereafter, he traveled to France and studied in the Parisian ateliers of Jean-Joseph Benjamin Constant and Jean-Paul Laurens. By this time both teachers were accomplished easel painters whose monumental decorative murals had inspired a generation of American students to practice this métier upon their return to the United States. While Guerin did indeed receive numerous decorative commissions during the 1920's, the final decade of his career, he is best known as an architectural delineator. This aspect of his work, well-recognized dur-

ing his lifetime, secured his reputation as an important proponent of the turn-of-the-century City Beautiful movement and the American Renaissance. An imaginative approach to architectural drawings made Guerin's work popular; throughout his career he was employed by such renowned architects as McKim, Mead, and White, Burnham, Carrère and Hastings, Cass Gilbert, Russell Sturgis, Henry Bacon, John Russell, and others.

During the 1890's, with the rapid rise of large commercial architectural firms, delineators played a vital role in the visualization of an architect's initial idea. For this reason their drawings were of great importance to both architect and patron as a preliminary visual expression of an architectural idea and as works of art in their own right.

Undertaken by architects John Galen Howard, F. H. Meyers, and John Reid, Jr., between 1913 and 1915, the San Francisco Civic Center, California, was designed with a centrally positioned City Hall, surrounded by an Opera House, Public Library, and Auditorium. Commissioned as a delineator for this project, Guerin executed this detailed rendering of the Civic Auditorium. He carefully articulated the entire structure, with its eclectic Beaux-Arts facade and fenestration, and animated the entire composition with subtle washes and figures in motion, giving the picture an extraordinary sense of reality.

JULES GUERIN (1866-1946)

27. Prayer in the Desert

Oil and pencil on canvasboard, 29¾ × 19½ in.

Signed (at lower left): Jules Guerin

Executed about 1907

RECORDED: Robert Hichens, *Egypt and Its Monuments* (1908), p. 175 illus. in color

In addition to being an architectural delineator, Guerin was well-respected for his work as an illustrator. As a means of making a livelihood, illustrative projects provided many artists of his generation—those who returned from Paris in the late 1870's and 1880's with impeccable art training but unable to sell their paintings—with work. Guerin's own involvement with illustration began near the end of the 1890's. Through his friend Maxfield Parrish,

he secured assignments with *Century Magazine*. By 1904, the success of a series of articles titled "The Chateaux of Touraine" (published first in *Century* and later as a book) accelerated his illustrative career, and led to additional commissions for two travel books by Robert Hichens. Inspired, in part, by the artist's excursions to Egypt, Greece, Turkey, and the Holy Land, *Prayer in the Desert* appeared as an illustration in Hichens' book, *Egypt and Its Monuments*, originally published by The Century Co., New York, in 1908.

Stylistically, this image shows a synthesis of Oriental and Occidental tendencies as they co-mingled during the late nineteenth century. Its compositional simplicity and flat color recall Japanese woodblock prints, while its mystical and exotic subject reflect fin-de-siècle symbolist painting, in particular the work of the Nabis.

JONATHAN SCOTT HARTLEY (1846-1912)

28. Lawrence Barrett as "Cassius"

Bronze, verdigris patina, 31½ in. high

Signed, dated, and inscribed (on the back): JS Hartley S^c NY 1884

Founder's mark (on the back): Bureau Bros./Founders Phila.

RECORDED: *cf.* Maria Naylor, ed., *The National Academy of Design Exhibition Record 1861-1900*, I (1973), p. 408 no. 432

Lawrence Barrett (1838-1891) was a well-known actor of his day and a good friend and biographer of the renowned Shakespearian actor Edwin Booth. Barrett's role as "Cassius" from William Shakespeare's *Julius Caesar* was certainly his most celebrated. His biographer, Elwyn A. Barron, recounted a story in *Lawrence Barrett, A Professional Sketch* (1889), p. 24:

Little did [Barrett] dream then there would be a time when the popular Edwin Booth should approach him after the glory of a splendid revival and say, with cordial deference, in highest compliment to the achievement of the younger actor, "I shall never play Cassius again." Indeed, since 1871 there has been but one Cassius.

Although Barrett played the dour Roman conspirator many times, it was as he was seen in an 1883 production of the play that Jonathan Scott Hartley portrayed him. Contemporary newspaper articles and photographs (Theatre Collection, New York Public Library of the Performing Arts, Lincoln Center, New York) show how faithfully Hartley recorded his face and costume.

Another cast of this subject was exhibited at the National Academy of Design, New York, in 1889, together with Hartley's companion bronze depicting *Edwin Booth as "Brutus"* of 1889. Both were lent by The Players [Club], New York, which Booth had founded in 1888 and of which Barrett was an incorporator, in whose collection they remain today.

Lawrence Barrett was also portrayed by two painters—in an 1882 full-length picture as "Cassius" in a toga by Francis D. Millet, and by John Singer Sargent [*cf.* William Howe Downes, *John S. Sargent: His Life and Works* (1925), p. 156, as exhibited at the National Academy of Design, New York, 1890, lent by The Players, New York].

JONATHAN SCOTT HARTLEY (1846-1912)

29. Whirlwind

Bronze, greenish-brown patina, 30½ in. high

Signed, dated, and inscribed (on the base):
WHIRLWIND/JS Hartley S.c./1896

Founder's mark (on the base): cire PerDue./GORHAM
CO.

RECORDED: *cf.* Lorado Taft, *The History of American Sculpture* (1903, revised ed. 1924, reprint 1969), p. 264 // *cf.* Maria Naylor, ed., *The National Academy of Design Exhibition Record 1861-1900*, I (1973), p. 408 no. 2

Jonathan Scott Hartley first exhibited a version of the *Whirlwind* at the National Academy of Design, New York, in 1878 [*cf.* Naylor, *op. cit.*, p. 407 no. 743]. About that work, Lorado Taft wrote [*loc. cit.*]: "Mr. Hartley's professional fame was made … by 'The Whirlwind,' which appeared in 1878, and was much complimented in its day for the originality of the thought and the vigor with which it was developed." The sculptor presumably remodeled the piece and exhibited this second version at the National Academy in 1896.

According to Michael Shapiro [*cf.* "Sculptors and Founders: An Overview of Bronze Casting in America, 1850-1900," in *Cast and Recast: The Sculpture of Frederic Remington* (1981), p. 34], the first known use in America of the lost-wax [cire perdue] method of casting was in 1896 at The Gorham Manufacturing Company of Providence, Rhode Island. Shapiro noted, however, that there "appeared to be little market or enthusiasm for the technique, and Gorham's commitment to lost-wax casting was short lived." The inclusion of the "cire perdue" notation on the present example indicates that it is one of these rare, early, lost-wax bronzes, presumably cast in 1896 or shortly thereafter.

Another bronze of the *Whirlwind*, cast by Bureau Brothers of Philadelphia, Pennsylvania, is in the collection of Brookgreen Gardens, Murrells Inlet, South Carolina.

F. CHILDE HASSAM (1859-1935)

30. Scene at the World's Columbian Exposition, Chicago, Illinois

Watercolor and gouache, en grisaille, on paper, 16½ × 13½ in.

Signed, dated, and inscribed (at lower left): Childe/ Hassam Chicago/1892

Unlike such other fledgling American Impressionists as J. Alden Weir and Robert Reid, Childe Hassam did not participate in the mural decorations of the Manufactures and Liberal Arts Building at the World's Columbian Exposition of 1893. However, he did travel to Chicago in 1892, prior to the completion and opening of the fair site, and executed a group of watercolors, seven of which are now in the collection of the Chicago Historical Society, which are documentary in nature—minutely-detailed architectural renderings, colored with washes.

More original in conception are a number of watercolor and gouaches, of which the present work is one, which chronicle various areas of the fair as buildings were completed. Examples of this type are found in the collec-

tions of the Fogg Art Museum, Harvard University, Cambridge, Massachusetts, and The Terra Museum of American Art, Evanston, Illinois. *Scene at the World's Columbian Exposition* appears to be the only work of the group that documents the actual construction of one of the fair buildings. Depicted is an unadorned corner of the Agricultural Building, one of the most elaborate and complicated structures at the fair. Located on the south side of the Court of Honor, the building was designed by the renowned New York architectural firm of McKim, Mead, and White. Although Augustus Saint-Gaudens' large sculpture of *Diana* sat atop the central dome of the building, much of the other statuary was executed by Philip Martiny (1858-1927), an Alsatian-born sculptor who assisted Saint-Gaudens. The sculpture seen at the left in Hassam's composition is one of the many identical figures by Martiny, each with the title *Genius of Abundance*, which was subsequently lifted to decorate a post above the Corinthian pilasters of the building.

This picture will be included in the forthcoming catalogue raisonné of Hassam's work, now in preparation by Stuart P. Feld and Kathleen M. Burnside.

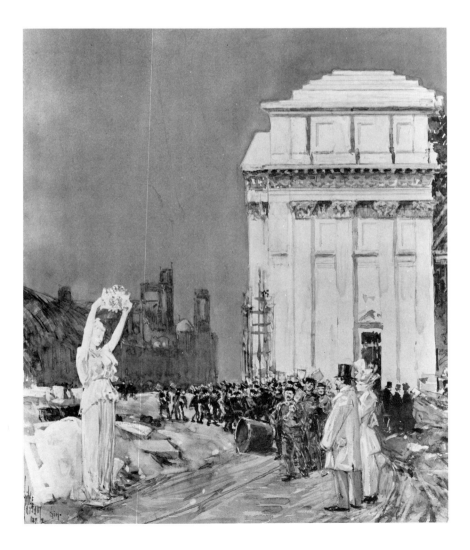

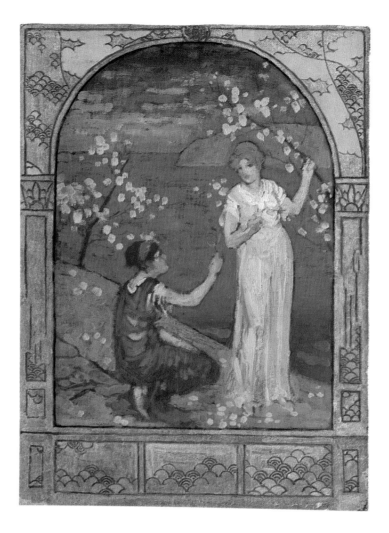

WILLIAM PENHALLOW HENDERSON (1877-1943)

31. Study for Overmantel Piece—Two Women in a Landscape

Oil and gold and silver leaf on canvas, 13¾ × 10 in.

Painted about 1915

EXHIBITED: Hirschl & Adler Galleries, New York, 1982, *William Penhallow Henderson: The Early Years, 1901-1916*, pp. 11 no. 13, 28 illus. in color

EX COLL.: the artist, until 1943; to the estate of the artist, 1943-82

Born in Medford, Massachusetts, Henderson studied under Edmund C. Tarbell at the Boston Museum School in 1899, then traveled through Europe from 1901 to 1904. During this time, he saw contemporary works by Post-Impressionists and members of the Nabis, and was strongly affected by James McNeill Whistler's tonal symphonies, as well as the decorative simplicity of Japanese prints, then popular in Europe. Henderson developed a decorative aesthetic that found expression in commissions for wall murals, panels, and friezes for numerous private residences, hotels, and public schools.

Study for Overmantel Piece—Two Women in a Landscape exemplifies Henderson's approach to decorative painting in the form of a preliminary oil study. The central composition, framed by a simulated arch and articulated with stylized floral patterns, is simply conceived and loosely executed. Ornamental rather than naturalistic, this study was conceived as a harmonious arrangement of forms and colors, a decorative ensemble intended to be compatible with its architectural setting.

ALBERT HERTER (1871-1950)

32. Two Women on Stairs

Watercolor and gouache on paper, 15¼ × 8⁹⁄₁₆ in.

Signed (at lower left): ALBERT HERTER

Executed in 1901

RECORDED: *The Ladies Home Journal* (Oct. 1901), as *Cover Design* // Letter, C. H. Ludington, Jr., Secretary and Treasurer, The Curtis Publishing Company, to Miss Florence Geckeler, March 4, 1907 (ms., Albert Herter file, Hirschl & Adler Galleries, New York)

EXHIBITED: National Gallery of Art, Washington, D.C., Amon Carter Museum, Fort Worth, Texas, and Los Angeles County Museum of Art, California, 1981-82, *An American Perspective: Nineteenth-Century Art from the Collection of Jo Ann & Julian Ganz, Jr.*, pp. 75, 76 fig. 72 in color, 77, 141-42 illus.

EX COLL.: The Curtis Publishing Company, Philadelphia, Pennsylvania, 1901; by gift to Miss Florence Geckeler, McKinley, Pennsylvania, March 4, 1907; [Hirschl & Adler Galleries, New York, 1979]; to Jo Ann and Julian Ganz, Jr., Los Angeles, California, 1979-82

In general Herter's work is characterized by harmonious arrangements of forms and colors. To add interest to his scenes, he often dressed his models in costumes and placed exotic objects within the composition. His interest in Oriental art was noted as early as 1895 [*cf.* George Parsons Lathrop, "Japan in American Art," in *The Monthly Illustrator*, V (July 1895), pp. 2-6]. *Two Women on Stairs* reflects Herter's keen interest in pattern and decorative detail, exotica (in the form of bonsai trees and drapery), and simplified formal arrangements. This image was commissioned for the cover of the October 1901 *Ladies Home Journal*.

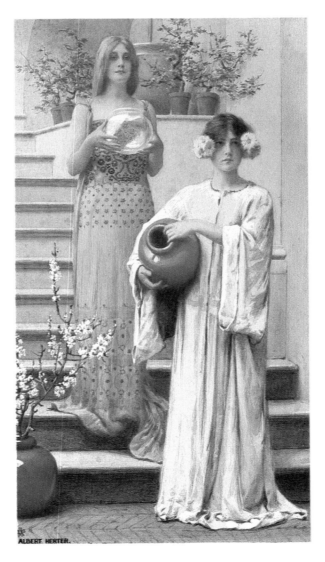

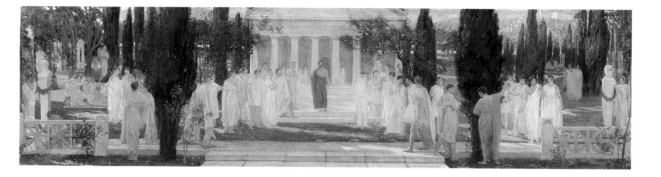

ALBERT HERTER (1871-1950)

33. Mural Study—Greek Philosophers

Oil on canvas, 26⅜ × 98⅛ in.

Painted about 1915-20

EXHIBITED: Santa Barbara Museum of Art, California, 1951, *Memorial Exhibit of the Paintings of Albert and Adele Herter*, [n.p.] no. 16, as *Sketch for Mural*, lent by Miss Pearl Chase

EX COLL.: Miss Pearl Chase, Santa Barbara, California, by 1951

During the American Renaissance, factors governing fine art and commercial production were often synonymous. Given the magnitude of certain commissions, efficiency was expected to harmonize with beauty. For example, a mural painter was frequently expected to paint in various "period" styles, depending on the commission. A ceiling mural for a drawing room might call for Rococo arabesques and pastel colors, while a wall mural for a wood-paneled library might require Italian Renaissance constraint, linear clarity, and symmetry. Eclecticism gave art commercial viability. An artist who exercised stylistic flexibility, efficiency, and dependability was considered a commercial asset; if he also had innate business sense and organizational inclinations, he could generate his own fortune. In this respect, Louis Comfort Tiffany epitomized the turn-of-the-century artist-cum-entrepreneur, but there were others.

Albert Herter was trained in Paris during the late 1880's and early 1890's. His father, Christian Herter, had also been an artist who specialized in decorative arts. After the young Herter returned from France in 1898, he was active as a mural painter, but he also did easel painting, illustration, set design, play writing, and textile design.

From the 1900's on, Herter painted murals for state capitols, private residences, hotels, and schools. Subjects based on American and ancient history, as opposed to Greek mythology, were the norm in his work. *Mural Study—Greek Philosophers* was intended as a study for one of his many decorative projects. A large, multi-figured composition whose horizontal format suggests a classical frieze, this study possesses the vitality of a working model. Soft color and light give the entire work a dreamlike quality; figures, clad in loose togas and arranged in small groups, interact within a setting that recalls an ancient civic forum.

The former owner of this work, Pearl Chase (1888-1979), was a contemporary of Herter's. A formidable woman, whose activites included social work, public health, city planning, and political reform, Chase was also a philanthropist who avidly supported the arts in Santa Barbara, California. Well-respected during her lifetime, she was honored by the denizens of her city, who bestowed on her the name, "Santa Barbara's Pearl."

FRANCIS COATES JONES (1857-1932)

34. Sappho

Oil on canvas, 22 × 32 in.

Signed and inscribed (at lower left): FRANCIS C. JONES/copyright

Painted about 1895

Generally known for his genre interiors of attractive, contemporary women engaged in domestic activities, Francis Coates Jones was also a part of the burgeoning classical movement that developed in American art towards the end of the nineteenth century. By 1895 he is known to have painted murals, as well as easel paintings, of antique themes. These paintings usually depicted women in classic dress situated indoors, but occasionally Jones would paint them in outdoor settings, as in *Sappho* and in another work titled *June*, for which the artist won a silver medal at the 1904 Universal Exposition, St. Louis, Missouri [*cf.* clipping file, W. G. Ball Collection, Boston Public Library, Massachusetts].

Sappho was a particularly popular subject among American artists at the turn of the century. Although some well-known conceptions at that time concentrated on her reputed lesbianism, the Americans generally ignored this aspect of her fame, depicting her as the traditional romantic ideal. Sappho was considered by many to be the greatest woman poet in history; as such, she virtually personified the predominant themes of the American Renaissance: the glorified female figure, classical civilization, and the poetic ideal. Jones' depiction of Sappho incorporates all of these elements into the composition. The two female figures at the left sit gracefully yet attentively, listening to their teacher's words, while Sappho, herself a delicate figure, holds a lyre representing the refinement of the arts.

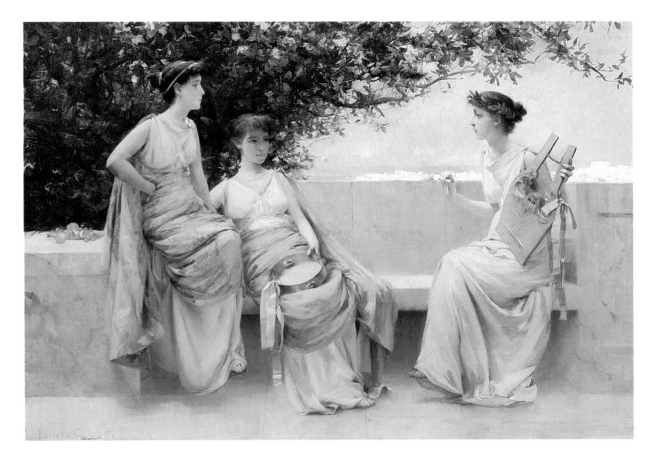

FRANCIS COATES JONES (1857-1932)

35. Woman in Classic Dress

Pastel on paper, 16¾ × 13¾ in. (sight size)

Signed (at lower right): FRANCIS C JONES

Executed about 1890-1900

EXHIBITED: National Gallery of Art, Washington, D.C., Amon Carter Museum, Fort Worth, Texas, and Los Angeles County Museum of Art, California, 1981-82, *An American Perspective: Nineteenth-Century Art from the Collection of Jo Ann & Julian Ganz, Jr.*, pp. 71 fig. 67, 72, 147 illus.

EX COLL.: [sale, Sotheby Parke Bernet, New York, Jan. 30-Feb. 2, 1980, no. 279]; to [Hirschl & Adler Galleries, New York]; to Jo Ann and Julian Ganz, Jr., Los Angeles, California, 1980-82

Until the later nineteenth century, the use of pastel in America was largely limited to portraits or sketches and studies. However, with the founding of the Society of Painters in Pastel, New York, in 1882, the medium, heretofore regarded as a "feminine art," gained acceptance and popularity among artists of the period, who began using it for finished works of art. Dianne H. Pilgrim, Curator of Decorative Arts, The Brooklyn Museum, New York, noted the newly-discovered benefits of the medium: "Pastel was a perfect vehicle for conveying [a] mood of intimacy, spontaneity and a concern with the effects of light and atmosphere" [Pilgrim, "The Revival of Pastels in Nineteenth-Century America: The Society of Painters in Pastel," in *The American Art Journal*, X (Nov. 1978), p. 44].

Francis Coates Jones, although not a member of the Society of Painters in Pastel, was certainly aware of the organization since his brother Hugh Bolton Jones was one of its founders, along with Edwin Blashfield, Robert Blum, William Merritt Chase, and others. Jones' *Woman in Classic Dress* is typical of pastels executed at this time; its intimate setting, careful handling of the medium, and atmospheric effects of light and shadow can be compared to such works as Chase's *Woman at the Window* (c. 1890, The Brooklyn Museum, New York) or Blum's *A Siesta* (1890-91, no. 6).

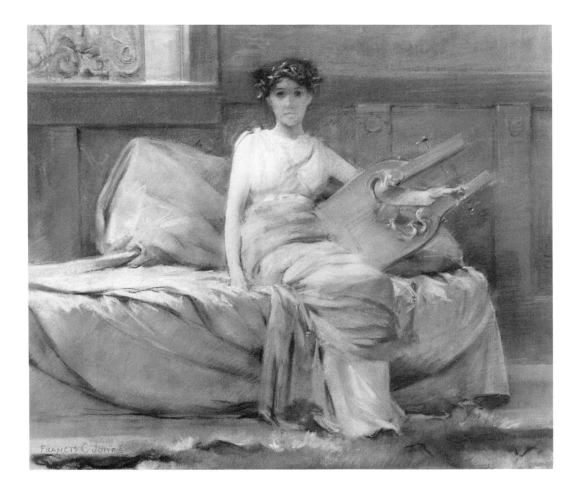

FRANCIS COATES JONES (1857-1932)

36. Lady and Lyre

Pastel on paper, 12½ × 15 in. (sight size)

Signed (at lower left): FRANCIS C JONES

Executed about 1900-10

EXHIBITED: National Gallery of Art, Washington, D.C., Amon Carter Museum, Fort Worth, Texas, and Los Angeles County Museum of Art, California, 1981-82, *An American Perspective: Nineteenth-Century Art from the Collection of Jo Ann & Julian Ganz, Jr.*, pp. 43, 71 fig. 66, 72-73, 109, 147 illus.

EX COLL.: [sale, Sotheby Parke Bernet, New York, April 20, 1979, no. 115 illus.]; to [Hirschl & Adler Galleries, New York]; to Jo Ann and Julian Ganz, Jr., Los Angeles, California, 1979-82

After the turn of the century, Jones' work became increasingly loose in execution. As in *Lady and Lyre*, he still focussed on women in interiors, but his style reflects the influence of Impressionism, by then acceptable even to conservative artists. The apparently gratuitous inclusion here of classical accoutrements shows the artist's continuing fascination with the antique.

LOUISE H. KING (1865-1945)

37. Primavera

Oil on canvas, 18 × 38⅝ in.

Signed (at lower left): LOUISE H. KING; dated (at lower right): 1892

EX COLL.: [Hirschl & Adler Galleries, New York, 1978-79]; to private collection, until 1984

Louise King was born in San Francisco, California, and studied painting at the National Academy of Design, and the Art Students League, both in New York, under Kenyon Cox, whom she later married.

Each of King's paintings was the result of numerous studies. Often using more than one model, the artist would concentrate on the most classically beautiful feature of each—the face, the hands, etc.—combining them in the finished painting to achieve a totally idealized rendering.

Although King's later works were primarily sentimental portraits of women and children, *Primavera* dates from the earlier part of her career when she concentrated on classical subjects.

JOHN LA FARGE (1835-1910)

38. Two Transom Windows from the Oliver Ames House, Boston, Massachusetts

Each, opalescent glass and pot-metal, 17 × 37½ in.

Executed in 1881

RECORDED: H. Barbara Weinberg, *The Decorative Work of John La Farge* (Ph.D. dissertation, Columbia University, New York, 1972; Garland Press, 1977), p. 353 footnote 2

EX COLL.: Oliver Ames House, Boston, Massachusetts, 1881-1978; to [Coe Kerr Gallery, New York, until 1980]; to private collection, Ridgewood, New Jersey

As early as 1874 La Farge began to experiment with stained glass. His proficiency in this medium was demonstrated early on in his elaborate program for Trinity Church, Boston, Massachusetts, and by the 1880's he had completed several important private commissions.

For the ground floor parlors of the Oliver Ames residence at 60 Massachusetts Avenue, Boston (now the National Casket Company), La Farge designed and executed several pairs of transom windows, two of which are represented here. A combination of pot-metal and opalescent glass, these transoms reflect a strong Oriental influence—abstract floral patterns and cherry blossoms—which characterized much of the artist's work at this time, in both stained glass and painting. Oliver Ames (1831-1895) was Governor of Massachusetts from 1886 until 1890.

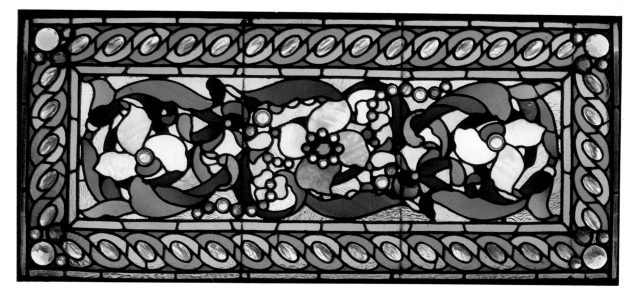

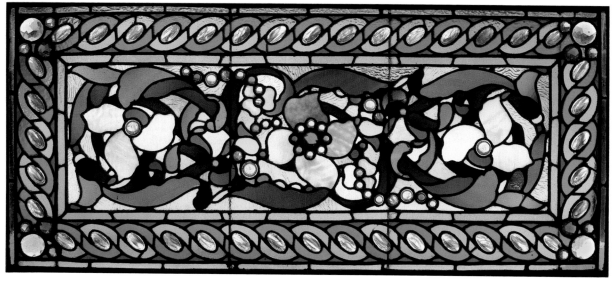

JOHN LA FARGE (1835-1910) and AUGUSTUS SAINT-GAUDENS (1848-1907)

39. Apollo with Putti

Banded African mahogany, repoussé bronze, colored marbles, mother-of-pearl, abalone shell, and ivory relief, 27⅝ × 63½ in.

Executed about 1881

RECORDED: "Art Notes: New York," in *The Art Journal*, VII (Oct. 1881), p. 318 // Mary Gay Humphreys, "The Cornelius Vanderbilt House: Decorations of the Dining-Room, Water-color Room, and Smoking Room," in *The Art Amateur*, VIII (May 1883), p. 135 // Frank Jewett Mather, Jr., "John La Farge: An Appreciation," in *The World's Work*, XXI (March 1911), p. 14091 plaster model illus. // Ruth Berenson Katz, "John La Farge as Painter and Critic" (Ph.D. dissertation, Radcliffe College, Cambridge, Massachusetts, 1951), p. 126 // H. Barbara Weinberg, *The Decorative Work of John La Farge* (Ph.D. dissertation, Columbia University, New York, 1972; Garland Press, 1977), p. 259 // John H. Dryfhout, "Augustus Saint-Gaudens' *Actaeon* and the Cornelius Vanderbilt II Mansion," in *The J. B. Speed Art Museum Bulletin*, XXXI (Sept. 1976), p. 5 fig. 3 plaster model illus. // Linnea Holmer Wren, "The Animated Prism: A Study of John La Farge as Author, Critic, and Aesthetician," (Ph.D. dissertation, University of Minnesota, Saint Paul, 1978), p. 106 footnote 70 // The Brooklyn Museum, New York, *The American Renaissance 1876-1917* (1979), p. 120 // John H. Dryfhout, *The Work of Augustus Saint-Gaudens* (1982), pp. 131, 132 no. 104-4 plaster model illus. // Henry A. La Farge, "John La Farge's Work in the Vanderbilt Houses," in *The American Art Journal*, XVI (Autumn 1984), p. 49

EX COLL.: Cornelius Vanderbilt, II, New York, about 1881-until 1899; to his estate, until about 1925-27, when the house for which this was executed was demolished.

Described by a contemporary critic [Humphreys, *loc. cit.*] as "the most important example of decorative work yet attempted in this country, in respect both to the scale on which it is employed and to its artistic intentions," the Cornelius Vanderbilt, II, House at 57th Street and Fifth Avenue, New York, was designed, constructed, and embellished between 1879 and 1883. Vanderbilt (1836-1899), financier, philanthropist, President of the New York and Harlem Railroad from 1886 until his death, and grandson of "Commodore" Cornelius Vanderbilt, chose the architect George Post (1837-1913) to design the mansion and contracted with John La Farge to provide elaborate interior decorations. La Farge's scheme included mural paintings (in which he was assisted by Will H. Low and Theodore Robinson, among others), mosaics, inlaid architectural ornament, opalescent and stained glass, tapestries, embroidered draperies, and sculptural ornament.

The sculptural program included various mixed-media bas-reliefs for the deeply coffered ceiling of the sumptuous Dining Room, "only paralleled in magnificence and in the luxuriousness of its material, by the decorative work of the fifteenth century" [*ibid.*]. La Farge, who knew and admired the work of the relatively young Augustus Saint-Gaudens from their previous association in the decoration of Trinity Church, Boston, Massachusetts, entrusted the sculptor with the preparation of the plaster models for these reliefs, the final carving and inlay being done in La Farge's New York studio. Among these Dining Room ceiling panels were *Ceres* (Saint-Gaudens National Historic Site, Cornish, New Hampshire), *Pomona, Bacchus, Actaeon* (all unlocated; plaster model of *Actaeon* in the J. B. Speed Art Museum, Louisville, Kentucky), and four *Apollo with Putti* panels for the corners. Until the recent discovery of the present relief, this image was only known through various contemporary descriptions and an archival photograph of Saint-Gaudens' original plaster model [*cf.* Dryfhout, *The Work of Augustus Saint-Gaudens*, p. 132 no. 104-4 illus.]. Saint-Gaudens also created the impressive marble mantelpiece with caryatids for the Entrance Hall, as well as three portrait reliefs of members of the Vanderbilt family.

Although the individual reliefs were admired, the Dining Room as a whole elicited a certain amount of criticism. According to Henry A. La Farge [*op. cit.*, p. 50], the ceiling was "considered too low for the proportions of the room, and the lighting was unsatisfactory, the glare from the skylights making it difficult to view the panels alongside."

In 1894-95 the house was greatly enlarged, eventually running the full block along Fifth Avenue between 57th and 58th Streets, at which time the Dining Room ceiling was dismantled and reinstalled in the new Billiards Room on the second floor. All of the La Farge/Saint-Gaudens panels, including the four *Apollo with Putti*, were placed at an angle between the ceiling and the walls in the new location; Saint-Gaudens' great mantelpiece was moved to the new site as well. The house was completely demolished between 1925 and 1927, at which time the mantelpiece was donated to The Metropolitan Museum of Art, New York, and the rest of the interior decorations were scattered.

This work will be included in the forthcoming catalogue raisonné of John La Farge's work, now in preparation by Henry A. La Farge.

JOHN LA FARGE (1835-1910)

40. Angel Holding Lyre

Watercolor on paper, 11 × 9½ in. (arched top)

Executed about 1884

RECORDED: Letter, Mary C. Wheelright to Henry A. La Farge, Feb. 23, 1934 (ms., La Farge Family Papers, folder 19), as *Design for Window of Angel Walking Up* // Letter, Henry A. La Farge to Stuart P. Feld, Hirschl & Adler Galleries, New York, Jan. 24, 1985 (ms., Hirschl & Adler archives)

EXHIBITED: Museum of Fine Arts, Boston, Massachusetts, 1911, *Memorial Exhibition of the Works of John La Farge*, [no. cat.]

ON DEPOSIT: Museum of Fine Arts, Boston, Massachusetts, 1936-41, as *Angel*

EX COLL.: Mary C. Wheelright, Boston, Massachusetts, by 1934-41; [sale, Blackwood Auction House, Essex, Massachusetts, Jan. 31, 1984]; to private collection, Providence, Rhode Island

Will H. Low, writing about La Farge following his death, praised him for his leading contribution to mural painting:

... it is in this field [mural painting], barren of contemporary honor, that many of our best figure painters, men whose larger culture comprised technical training equal to the best of their followers, chose to labor; and it is here John La Farge was at once the dean and leader.... ["John La Farge: Mural Painter," in *The Craftsman* (Jan. 1911), p. 338]

Low's last three words, "dean and leader," would equally apply to La Farge's involvement with stained glass. Studying early medieval prototypes, and inspired by Renaissance and Oriental art, he innovated new techniques and extended the possibilities of this medium. Anticipating the mass production of stained glass by Louis C. Tiffany, J. & R. Lamb Studios, and D'Ascenzo Studios, La Farge revived the practice of stained glass in America with the same conviction and artistic experimentation that characterized his mural painting in 1876 at Trinity Church, Boston, Massachusetts.

According to Henry A. La Farge, grandson of the artist, *Angel Holding Lyre* was undoubtedly a design for a stained glass window; however, no window based upon it has been found. This watercolor, dated to about 1884, will be included in La Farge's forthcoming catalogue raisonné on John La Farge.

JOHN LA FARGE (1835-1910)

41. Mater Dolorosa

Watercolor and pencil on paper, tondo, 9 in. (diameter)

Inscribed (from top to bottom): THIS · SPACE · FOR · INSCRIPTION · OR · TEXT/TO · TAKE · UP · SAME · SPACING · AS · IN · THE · OTHER/CIRCULAR · WINDOWS · IN · THE/ · JUDSON · CHURCH ·

Executed in 1904

EX COLL.: estate of the artist; Alden Sampson, Washington, D.C.; Professor E. Sampson

RECORDED: cf. H. Barbara Weinberg, *The Decorative Work of John La Farge* (Ph.D. dissertation, Columbia University, New York; Garland Press, 1977), pp. 410-12

This work is a study for one of the stained glass windows in the Judson Memorial Church on Washington Square, New York, designed by Stanford White of McKim, Mead, and White. The church's important program of stained glass was entirely designed by John La Farge. *Mater Dolorosa* relates to a window on the west wall of the church, created to the memory of Delphine Antisdel (1844-1904), whose name and dates are included in the inscription on the actual window.

This work will be included in the forthcoming catalogue raisonné of the work of John La Farge, now in preparation by Henry A. La Farge.

JOHN LA FARGE (1835-1910)

42. Presentation of Gifts and Speech-making, Samoa

Watercolor, en grisaille, on paper, 16 × 12 in. (sight size)

Signed, dated, and inscribed (at lower right): LAF/IVA Samoa, 1890; (on the back): Presentation of Gifts/and Speech-making/John La Farge

RECORDED: *cf.* Durand-Ruel Galleries, New York, *Works by John La Farge* (1895), pp. 31-33 // *cf.* Royal Cortissoz, *John La Farge: A Memoir and a Study* (1911), facing p. 242 illus. // *cf.* John La Farge, *Reminiscences of the South Seas* (1912), facing p. 262 illus.

EXHIBITED: M. Knoedler & Co., New York, 1909, *Glass, Oil and Water Color Paintings and Sketches by John La Farge, N.A.*, [n.p.] no. 45, as *Presentation of Gifts and Food on Manono Island, November 22, 1890*, $500.00, lent by the artist // New York State Council on the Arts, circulated by The American Federation of Arts within New York State, 1962-63, *Masters of American Watercolor*, [n.p.] no. 21, lent by J. William Middendorf // The Baltimore Museum of Art, Maryland, and The Metropolitan Museum of Art, New York, 1967, *American Paintings and Historical Prints from the Middendorf Collection*, pp. 48 no. 33, 49 illus., as *Presentation of Gifts and Speechmaking, Vao-Vai, Samoa* // Bruce Museum, Greenwich, Connecticut, 1970, *American 19th and 20th Century Paintings*, [no. cat.] // Peabody Museum, Salem, Massachusetts, 1978, *Paintings, Watercolors and Drawings by John La Farge from His Travels in the South Seas, 1890-1891*, p. 9 no. 5, as *Presentation of Gifts of Food on Manono Island, Samoa*, lent by Graham Galleries, New York

EX COLL.: the artist, 1890-1910; to estate of the artist, 1910-11; to [sale, American Art Galleries, New York, March 29-31, 1911, *Art Properties and Other Objects Belonging to the Estate of the Late John La Farge, N.A.*, (n.p.) no. 846]; to Dorothea Dreier, New York, in 1911; J. William Middendorf, by 1962-67; [Graham Gallery, New York, 1970-82]

From 1890 to 1891 La Farge made an extensive journey to the South Seas, stopping first in Hawaii before traveling on to Samoa, Tahiti, and the Fuji Islands. The details of his trip were methodically recorded in his many letters and in the form of sketches and watercolors, executed from memory or on the spot. Intrigued by strange tribal customs and rituals, La Farge recorded these new experiences in the spirit of a contemporary anthropologist. Executed while he was staying in Vao-Vai on Samoa, *Presentation of Gifts and Speechmaking* depicts a gathering of Tulafales within the village. In his letters, La Farge mentioned on more than one occasion the long speeches made by Tulafales—important members of the village, a shaman, chief, or a chief's son or daughter. Sometimes these gatherings were formal ceremonies with elaborate procedures; other times they were informal meetings where Tulafales gathered to make speeches, socialize, and drink kava.

La Farge's South Sea excursions were part of a greater cultural imperialism, which, by the 1890's, had expanded overseas beyond America. As an artist, however, La Farge was motivated by aesthetics, a quest for novel experiences and subject matter, and not for new commercial markets. The romantic desire to experience new worlds and cultures affected artists as well as government and business; the objectives in each case, however, were quite different.

La Farge painted an almost identical version of *Presentation of Gifts and Speechmaking, Samoa* in watercolor (collection of Edward H. La Farge, Providence, Rhode Island).

This watercolor will be included in Henry A. La Farge's forthcoming catalogue raisonné of the artist's work.

FREDERICK STYMETZ LAMB (1863-1928)

43. Faithfulness

Opalescent glass and pot-metal, 82 × 29 in. (sight size)

Executed in 1907

EX COLL.: Reformed Church of Westwood, New Jersey, 1907-82; private collection, Spring Valley, New York

By 1907 J. & R. Lamb Studios, run by Charles Rollinson and Frederick Stymetz Lamb, was one of the largest and best-known decorative art studios in America. Founded in 1857, with numerous workshops in New York City, the Lamb brothers mass produced stained glass, mosaics, wood carving and furniture, embroidery, mural painting, and general interior decoration. The majority of their work was ecclesiastical; they were the first commercial decorative firm to specialize in this area. By the 1890's Lamb's original line of Gothic Revival decoration had shifted to a more classical order influenced by the burgeoning American Renaissance.

Faithfulness was executed along with a related window, *Charity*, whose present location is unknown. Its design was patterned after similar windows illustrated in the Lamb portfolio. The final design of this particular window was modified to suit the commission, and Frederick Lamb was responsible for the selection of glass and lead patterning. As was Lamb's method, the window was double-plated in selected passages to introduce modeling and texture. *Faithfulness* is a personification of this virtue, represented by a woman, a domestic weaver who bears spun fiber in her left arm and a cloth in her right. The slightly lowered position of her head and her earnest expression reinforce the notions of faith and humility. Drapery is given a classical weight, the result of "drapery glass" folded in its molten state to give a three-dimensional effect. The architectural border around the perimeter of the image was intended to integrate the window with its ecclesiastical setting.

WILL H. LOW (1853-1932)

44. Basket of Oranges

Oil on canvas, 37¼ × 19¼ in.

Signed and inscribed (at lower right): WILL H. LOW
NEW YORK

Painted about 1885

Originally from Albany, New York, Will H. Low quickly became active in international art circles. Arriving in New York in 1870, he worked as an illustrator for several years before embarking for London and Paris. He spent the next five years, from 1873 to 1877, in Paris, studying painting first under Jean-Léon Gérôme and later in the atelier of Carolus Duran. Like Kenyon Cox, Edwin Blashfield, and H. Siddons Mowbray, Low optimistically forecast a renaissance in America of mural painting. In actuality, the viability of practicing mural painting, even

after its popular success at the World's Columbian Exposition, Chicago, Illinois, in 1893, was rarely realized. Out of necessity, Low worked at diverse jobs that included illustration and teaching; even at the height of his mural painting career he continued to paint easel pictures.

Basket of Oranges reflects Low's preference for classical subjects, painted in a dreamy, languorous style. Recalling work by F. D. Millet (no. 55), H. Siddons Mowbray (no. 58), and other such pictures by Low as *Purple and Gold* (1889, National Academy of Design, New York), in which a single female figure holds a garland of flowers or basket of fruit and is posed within a landscape or minimal architectural setting, this picture embodies the ideality and classical revery that distinguishes it as a work of the American Renaissance.

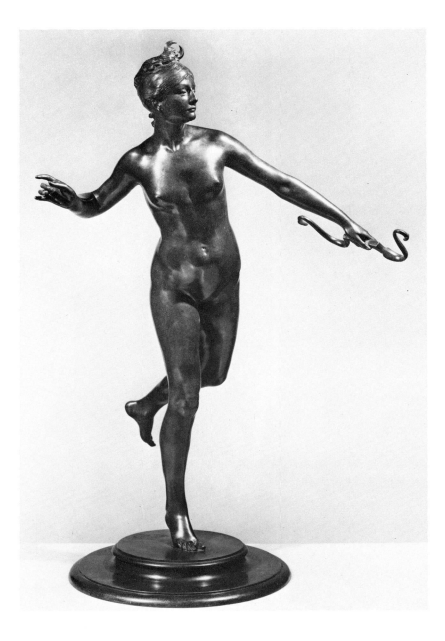

FREDERICK MacMONNIES (1863-1937)

45. Diana

Bronze, dark brown patina, 31¼ in. high

Signed, dated, and inscribed (on the base):
F MacMonnies 1890 Copyright 1894

Founder's stamp (on the base): E. GRUET/JEUNE/FON-
DEUR/44^BIS AVENUE DE CHATILLON/PARIS

RECORDED: *cf.* Lorado Taft, *The History of American
Sculpture* (1903, revised ed. 1924, reprint 1969), pp. 335-36
// *cf.* Wayne Craven, *Sculpture in America* (1968), p. 421 //
cf. Beatrice Gilman Proske, *Brookgreen Gardens Sculp-
ture* (revised and enlarged ed., 1968), p. 33 // *cf.* University
Art Galleries, University of Nebraska, Lincoln, *American
Sculpture* (1970), [n.p.] no. 102 illus.

EX COLL.: C. Ledyard Blair, in 1908; estate of Florence Blair
Pyne, until 1984

At the time MacMonnies modeled the *Diana*, he was an
assistant in the Paris studio of the Beaux-Arts master Jean-
Alexandre-Joseph Falguière, whose influence may be
seen in the work. MacMonnies entered the work in the
1889 Paris Salon where it won an honorable mention. It
was the sculptor's first international award.

Diana was produced in two sizes, the present one and
another measuring 19 inches high. Other castings in the
large size are in the collections of The Metropolitan
Museum of Art, New York, and the University of Nebraska
Art Galleries, Lincoln, among others.

FREDERICK MacMONNIES (1863-1937)

46. Nathan Hale, Founder's Original

Bronze, dark brown patina, 28¾ in. high

Signed and dated (on the base): F. MacMonnies 1890

RECORDED: *cf.* Albert TenEyck Gardner, *American Sculpture: A Catalogue of the Collection of the Metropolitan Museum of Art* (1965), pp. 84, 85 illus. // *cf.* Wayne Craven, *Sculpture in America* (1968), pp. 422, 456 fig. 12.1 // *cf.* Lewis I. Sharp, *New York City Public Sculpture by 19th-Century American Artists* (1974), pp. 36 illus., 37 // *cf.* The Brooklyn Museum, New York, *The American Renaissance 1876-1917* (1979), p. 226 no. 247 illus. // David Weir, "Old Bronze/New World," in *Art/World*, VI (April-May 1982), p. 9

EXHIBITED: Hirschl & Adler Galleries, New York, 1982, *Carved and Modeled: American Sculpture 1810-1940*, p. 63 no. 32 illus. in color

EX COLL.: Family of the sculptor, until 1981

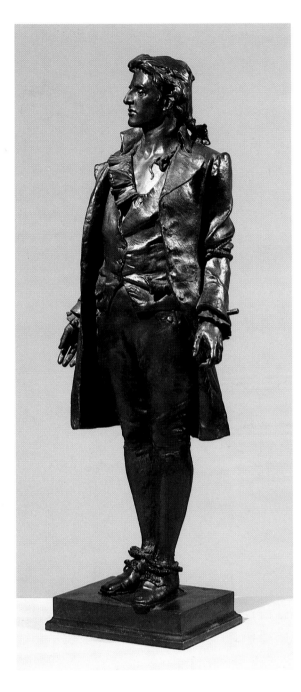

This bronze is a reduction of the statue of *Nathan Hale* in City Hall Park, New York, dedicated in 1893. MacMonnies entered the competition for the monument at the suggestion of Augustus Saint-Gaudens and sculpted a full-size model in his Paris studio in 1890. A year later, he exhibited the large plaster at the Paris Salon. Since no contemporary portrait of Hale (1755-1776) was available, MacMonnies created an imaginary likeness of the patriot and portrayed him as defiant in the moment before his hanging. The statue was originally located on the west side of the Park at the approximate spot where Hale was tried and hanged.

Due to the popularity of MacMonnies' work, many bronze replicas were made in reduction and widely sold during his lifetime. In order to maintain sharpness and clarity of detail in the numerous bronze casts, it became necessary to make a master in bronze—rather than the more fragile plaster—from which subsequent bronzes could then be taken. In the casting process, certain parts would be made separately and later assembled; therefore, the hands and base of this "founder's original" are detachable.

Other versions, probably taken from this master bronze, are in the collections of The Metropolitan Museum of Art, New York, and The Art Museum, Princeton University, Princeton, New Jersey, among others.

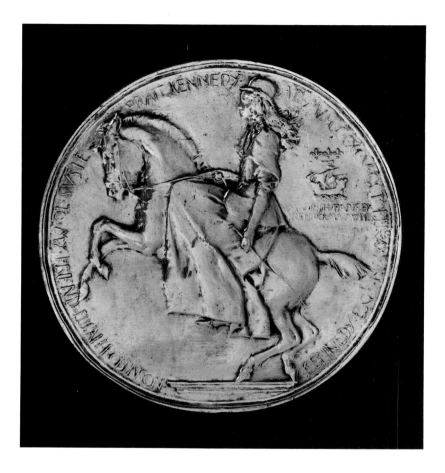

FREDERICK MacMONNIES (1863-1937)

47. Susie Pratt Kennedy

Silver on copper relief, roundel, 7¾ in. (diameter)

Signed and inscribed (at center right): MADE · IN · PARIS · BY ·/FREDERICK · MACMONNIES; inscribed and dated (along the rim): SVSIE PRATT KENNEDY · · A · D · M · D · C · C · C · X · C · V · OCTOBER · XXX · I · [October 31, 1895] · TO · MY · FRIEND · ELIJAH · ROBINSON · KENNEDY · ESQ^R

RECORDED: *cf.* Angus Helly, "An American Diana Vernon," in *The Brooklyn Eagle* (May 3, 1896), drawing of relief illus.

EXHIBITED: Hirschl & Adler Galleries, New York, 1982, *Carved and Modeled: American Sculpture 1810-1940,* p. 67 no. 36 illus.

EX COLL.: Family of the sculptor, until 1981

Susan Pratt Kennedy was the daughter of the Brooklyn, New York, Park Commissioner and friend of the sculptor, Elijah R. Kennedy. At the time this relief was modeled, Miss Kennedy was fifteen years old.

MacMonnies exhibited a large bronze version (36 in. diameter) of this relief at the spring exhibition of the 1896 Paris Salon.

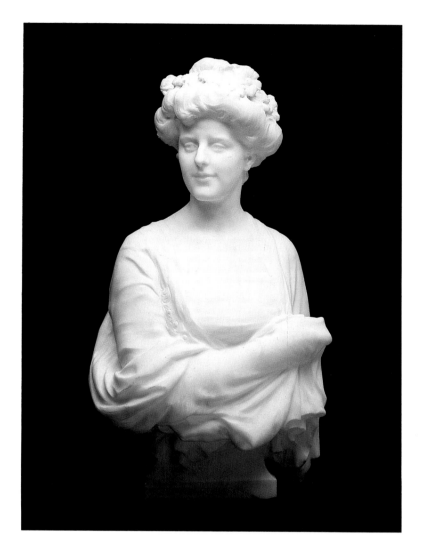

FREDERICK MacMONNIES (1863-1937)

48. Bust of Eleanor Draper

Marble, 36 in. high

Signed and inscribed (on the base): MAC-MONNIES/
PARIS

Executed about 1895-1900

EXHIBITED: Hirschl & Adler Galleries, New York, 1984,
The Art of Collecting, p. 38 no. 26 illus. in color

EX COLL.: Descendants of the sitter, until 1983

MacMonnies spent the majority of his artistic life in France,
where he established his reputation as a bronze sculp-
tor. Rarely did he produce works in marble, but notable
among the exceptions are the *Bacchante with Infant Faun*
(The Brooklyn Museum, New York) and *Venus and
Adonis* (Brookgreen Gardens, Murrels Inlet, South
Carolina), both of which were also cast in bronze.

The *Bust of Eleanor Draper*, commissioned by an Ameri-
can family while MacMonnies was living in Paris, is an
engaging portrait created during the Belle Epoque. It
appears to exist only in marble.

An old photograph of the work, formerly in the sculptor's
personal archives at his home in Giverny, France,
accompanies this sculpture.

FREDERICK MacMONNIES (1863-1937)

49. Bacchante with Infant Faun

Bronze, greenish-brown patina, 67¾ in. high

Signed (on the base): F [?] MacMonnies

Model executed between 1893 and 1894

RECORDED: Hildegard Cummings, "Chasing a Bronze Bacchante," in The William Benton Museum of Art, The University of Connecticut, Storrs, *Bulletin* (1984), pp. 12, 14

One of the great public scandals at the end of the nineteenth century was the installation of Frederick MacMonnies' full-size *Bacchante with Infant Faun* (bronze, 83 in. high) in the courtyard of the newly-completed Boston Public Library, Massachusetts, an important architectural monument of the American Renaissance. It was the sculptor's first major effort after his great success at the 1893 World's Columbian Exposition, Chicago, Illinois, with the enormous *Barge of State*, and was a gift from the Library's architect, Charles McKim, of the New York firm of McKim, Mead, and White. The *Bacchante* was only in place for three months in 1896 when the Art Commission of the City of Boston voted to reject it. According to Frederick O. Prince, a Library Trustee and the only vote accepting it, the Commission was concerned with erecting a "monument to inebriety" in conservative Boston [Cummings, *op. cit.*, p. 3]. McKim withdrew his offer and presented the piece in 1897 to The Metropolitan Museum of Art, New York, where it is today. Two additional full-size bronzes are known (Town Hall, Selestat, France, formerly in the Luxembourg Museum, Paris, and the Museum of Fine Arts, Boston, Massachusetts), as well as two full-scale marble replicas (The Brooklyn Museum, New York, and the William Randolph Hearst Collection, San Simeon, California).

MacMonnies is known to have made three three-quarter scale bronzes (approx. 68 in. high) of the subject, as recorded in a letter dated January 7, 1931, from him to Max Farrand at the Henry E. Huntington Library and Art Gallery, San Marino, California [reprinted in *ibid.*, pp. 12-14]:

> The "Bacchante" on the Huntington grounds is a smaller version of the original in the Metropolitan Museum, and was made in that scale for small gardens or courtyards, in fact, for just such a place as it occupies at San Marino....Of the San Marino size, Mrs. Southern, formerly Julia Marlowe, owns one and one other, of which I have lost track, exists somewhere.

The *Bacchante* in the Huntington Library—unsigned, with no foundry mark—remains there today. The version owned by Julia Marlowe, a Shakespearian actress, is presumably the same as the one now in an educational institution in Santa Barbara, California. It bears a Jaboeuf & Rouard, Paris, founder's stamp. The present bronze, recently discovered in Paris, must therefore be the one of which MacMonnies had "lost track."

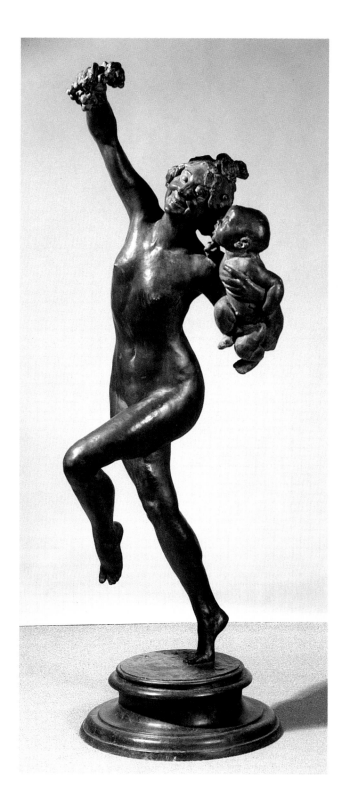

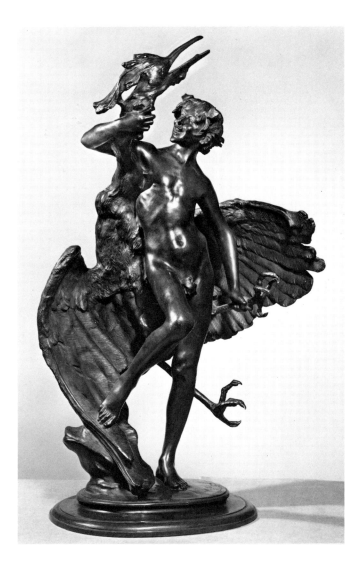

FREDERICK MacMONNIES (1863-1937)

50. Boy and Heron

Bronze, dark brown patina, 27 in. high

Signed, dated, and inscribed (on the base): Frederick MacMonnies/Copyright 1894 Paris 1890

Founder's stamp (on the base): JABOEUF & ROUARD/ FONDEURS A PARIS

RECORDED: *cf.* Albert TenEyck Gardner, *American Sculpture: A Catalogue of the Collection of the Metropolitan Museum of Art* (1965), pp. 82-83 illus., as *Young Faun and Heron* // *cf.* Wayne Craven, *Sculpture in America* (1968), p. 422, as *Young Faun and Heron* // *cf.* The Detroit Institute of Arts, Michigan, *The Quest for Unity: American Art Between World's Fairs 1876-1893* (1983), pp. 158-59 no. 79 illus.

Boy and Heron was originally commissioned as a six-foot fountain figure for the residence of the lawyer and later Ambassador Joseph A. Choate, Stockbridge, Massachusetts. The house, known as "Naumkeag," was designed by Stanford White of the New York architectural firm of McKim, Mead, and White. MacMonnies completed the work in 1890 and exhibited it that year at the Paris Salon. In 1894 he copyrighted *Boy and Heron* and arranged with a Paris foundry to cast reductions of the piece. He exhibited one of the bronze reductions that year at the Antwerp art exhibition, Belgium, and, in 1895, at the Boston Art Club, Massachusetts, winning first prize at each.

In the catalogue to the 1983 exhibition, *The Quest for Unity* [*op. cit.*, p. 159], Michele Bogart wrote:

> Newspaper clippings from 1895-96 attest to its critical popularity; the statuette was praised for its vitality, joyful spirit, and strong, picturesque modeling. It is this play of light and dark over the statuette's surface, its formal and compositional unity, that lead critics to link its spirit to that of Renaissance fountain sculpture; the image of a child playfully grasping a water animal dates back to such quattrocento fountain figures as Verrocchio's *Putto and Dolphin* (Florence, Palazzo Vecchio), itself drawn from antiquity.

HERMON ATKINS MacNEIL (1866-1947)

51. Girl with Young Satyr

Bronze, dark brown patina, 23 in. high

Signed (on the base): H. A. MacNeil; numbered (under the base): Nº 3

Founder's mark (on the base): ROMAN BRONZE WORKS N.Y.

Executed about 1910-15

RECORDED: *cf.* John E. D. Trask and J. Nilsen Laurvik, eds., *Catalogue De Luxe of the Department of Fine Arts, Panama-Pacific International Exposition*, II (1915), p. 442 no. 3280

EXHIBITED: Hirschl & Adler Galleries, New York, 1982, *Carved and Modeled: American Sculpture 1810-1940*, p. 73 no. 42 illus.

MacNeil exhibited the *Girl with Young Satyr* at the 1915 Panama-Pacific International Exposition, San Francisco, California. For it, along with another work titled *Incoming Wave* and four medals, he won a gold medal.

ARTHUR FRANK MATHEWS (1860-1945)

52. Ladies on the Grass

Oil on canvas, 48 × 52 in.

Painted about 1915

EXHIBITED: The Oakland Museum, California, Santa Barbara Museum of Art, California, Fine Arts Gallery of San Diego, California, Milwaukee Art Center, Wisconsin, Cincinnati Art Museum, Ohio, and The New York Cultural Center, New York, 1972-73, *Mathews, Masterpieces of the California Decorative Style*, p. 88 no. 46 // Hirschl & Adler Galleries, New York, 1980, *American Art from the Gallery's Collection*, p. 90 no. 75 illus. in color

EX COLL.: Mr. and Mrs. Robert Crutchfield, San Francisco, California, in 1972

Initially trained as an architect in his family's practice, Mathews later traveled to Paris, entered the Académie Julian, and, from 1885 to 1889, studied under Gustave Boulanger and Jules Lefebvre. In 1890 he was appointed Director of the California School of Design, San Francisco, and in 1906 he co-founded, with his wife Lucia and John Zeile, the Furniture Shop. Specializing in interior decoration, furniture design, wood crafts, architectural design, projects in city planning, writing, and publications, the Furniture Shop served as a forum for the dissemination of Mathews' ideas and formulated the basis of what later became known as the California Decorative Style.

Ladies on the Grass demonstrates Mathews' preoccupation with the female form, decorative compositional devices, flattened planes of muted color, and simplified arrangements. The solidity and modeling of his figures, reinforced by his Parisian training, reflects his debt to Greco-Roman classicism; the decorative simplicity recalls Oriental art and the muted Arcadian allegories of Puvis de Chavannes.

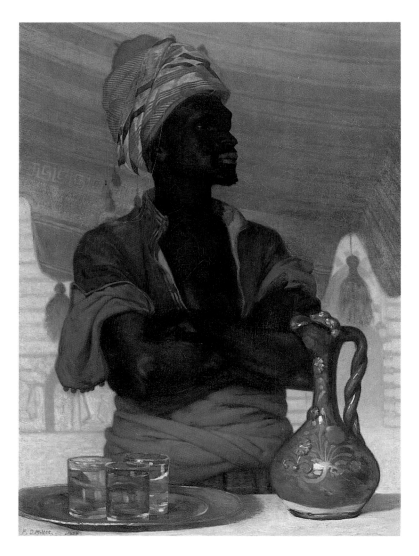

FRANCIS DAVIS MILLET (1846-1912)

53. Turkish Waterseller

Oil on canvas, 40 × 28 in.

Signed and dated (at lower left): F. D. Millet 1874

RECORDED: *cf.* H. Barbara Weinberg, "The Career of Francis Davis Millet," in *Archives of American Art Journal,* XVII (1977), p. 4 // *Arabian Horse World* (May 1983), p. 362 illus.

EXHIBITED: *cf.* Bruxelles, Belgique, 1875, *Exposition Général des Beaux-Arts,* p. 108 no. 831, as *Taxim Son! Vendeur d'eau à Pera (Constantinople); étude*

EX COLL.: estate of the artist, until 1981

During Millet's career, terminated by the tragic sinking of the Titanic, he sustained extraordinary versatility and diverse interests. An accomplished writer, easel painter, muralist, illustrator, and designer of stained glass, he also served on numerous fine art committees and juries. Commanding many languages and a knowledge of American and European history, he was at home in art circles in America, England, and Europe.

After graduating in 1869 from Harvard College, Cambridge, Massachusetts, Millet studied at the Royal Academy of Antwerp, Belgium, from 1871 to 1873. Following his graduation, he was appointed secretary to Charles Francis Adams, Jr., Commissioner of the State of Massachusetts to the Vienna Exposition, Austria. From 1873 to 1875 Millet traveled extensively throughout Hungary, Turkey, Rumania, and Italy. His art matured during this *wanderjahre*, and according to Weinberg [*loc. cit.*]: "In 1875, Millet's expanded travels and his maturing style were reflected in two paintings that he submitted to the Brussels Salon, the first major exhibition in which his participation is recorded. One of these was a study of a Turkish waterseller . . . , the appearance of which is unknown."

Given the model and accoutrements of this picture, in all likelihood it is the Turkish waterseller that Millet exhibited in the 1875 Brussels Salon.

FRANCIS DAVIS MILLET (1846-1912)

54. Thesmophoria

Oil on canvas, 25 × 50¼ in. (sight size, arched top)

Signed (at lower left): F. D. Millet

Painted between 1894 and 1897

RECORDED: *cf.* Charles H. Caffin, "Frank D. Millet's Mural Painting for Pittsburgh," in *Harper's Weekly*, XLI (Dec. 25, 1897), pp. 1294-95 illus. // *cf.* Pauline King, *American Mural Painting* (1902), pp. 252, 254 illus., 255 // H. Barbara Weinberg, "The Career of Francis Davis Millet," in *Archives of American Art Journal*, XVII (1977), pp. 13, 14 fig. 23, 18 // *cf.* Trudy Baltz, "Pageantry and Mural Painting," in *Winterthur Portfolio*, XV (1980), p. 224 fig. 18

EXHIBITED: Hirschl & Adler Galleries, New York, 1980, *American Art from the Gallery's Collection*, p. 76 no. 62 illus. in color

By 1893 mural painting had become an important aspect of Millet's oeuvre. His earliest involvement with this métier was in 1876 as an assistant to John La Farge at Trinity Church, Boston. Like other assistants then employed by La Farge—John du Fais, George Maynard, Francis Lathrop, Augustus Saint-Gaudens, Sidney L. Smith, and Edwin G. Champney—Millet was responsible for executing a myriad of decorative details.

Millet's personal contribution to mural painting was formalized when he accepted a position as Director of Decorations for the World's Columbian Exposition, Chicago, Illinois, in the spring of 1892. In addition to being Director of Decorations, he also designed and executed murals for the Manufactures and Liberal Arts Building and a ceiling in the Banquet Hall of the New York State Building. After Chicago, he received a commission to paint a mural for the Bank of Pittsburgh, Pennsylvania, a project he completed over the next three years, from 1894 to 1897, working out of his Broadway studio in the Cotswolds, England. The mural was installed in the bank's main hall opposite Edwin Blashfield's allegory, *Manufacture*.

Executed as an easel painting, *Thesmophoria* is the finished study for the Pittsburgh mural. Millet's program depicts a procession enacting the ancient Athenian festival honoring Demeter, the Greek Goddess personifying agriculture and the civic rite of marriage. According to the ancient custom, women offered sacrifices for three days each year in Demeter's temple on the promontory of Colias, then returned to Athens at the conclusion of the festival. On each occasion a lady of nobility was chosen to act as priestess. She is represented here walking within the main procession, but is distinguished by her yellow "peplos" edged with gold and a thimble staff from which incense rises. Millet often used contemporary models for his subjects; the priestesses were modeled after the American actress Mary Anderson (Madame M. Antoinette Anderson de Navarro), Mrs. Lawrence Alma-Tadema, Mrs. Phil May, and two daughters of Frederick Barnard, all close neighbors of the Millets in the village of Broadway. The Bank of Pittsburgh and its entire decorative program was demolished in 1944.

The painting retains its original tabernacle-style frame in the taste of the American Renaissance.

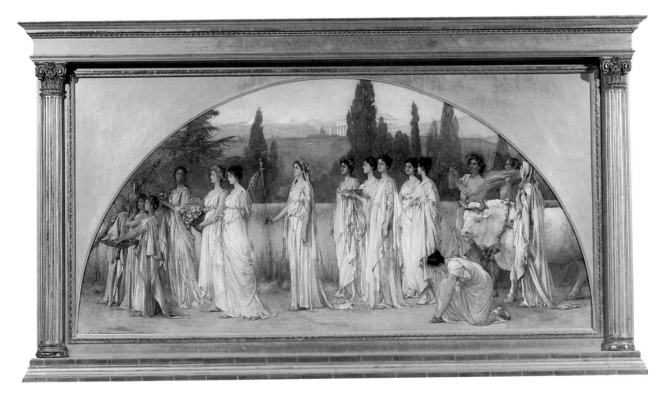

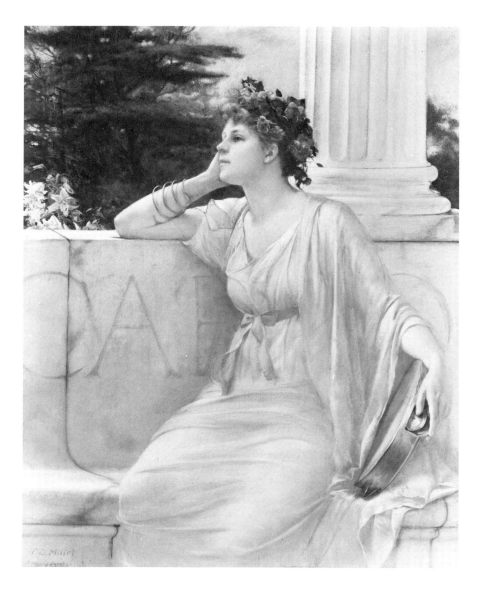

FRANCIS DAVIS MILLET (1846-1912)

55. After the Festival

Oil on canvas, 20 × 16⅛ in.

Signed and dated (at lower left): F. D. Millet/1888

EXHIBITED: National Gallery of Art, Washington, D.C., Amon Carter Museum, Fort Worth, Texas, and Los Angeles County Museum of Art, California, 1981-82, *An American Perspective: Nineteenth-Century Art from the Collection of Jo Ann & Julian Ganz, Jr.*, pp. 77 fig. 76 in color, 78-79, 109, 152 illus.

EX COLL.: William T. Evans, New York; to [sale, American Art Galleries, New York, Jan. 31-Feb. 2, 1900, no. 13]; [Hirschl & Adler Galleries, New York, 1978]; to Jo Ann and Julian Ganz, Jr., Los Angeles, California, 1978-82

Like others of his generation, Millet created genre paintings that relied on historical research and archeological accuracy. By 1875, three years after his graduation from the Royal Academy, London, he had begun to produce pictures in which historical costume and specificity of ambience were central concerns.

Millet's exclusive devotion to classical subjects began about 1882 and continued until 1888, after which he painted antique themes intermittently until 1897 [*cf.* H. Barbara Weinberg, "The Career of Francis Davis Millet," in *Archives of American Art Journal*, XVII (1977), p. 7]. While his characterization and treatment of this classic genre recalled the work of Lawrence Alma-Tadema, whose style he knew by 1882, affinities with this English master were perhaps more inspirational than influential. *After the Festival* is an example of Millet's interpretation of this genre. While its accoutrements—classical drapery, architectural motives, and jewelry—recall the antique, the facial expression of his model introduces a level of contemporaneity.

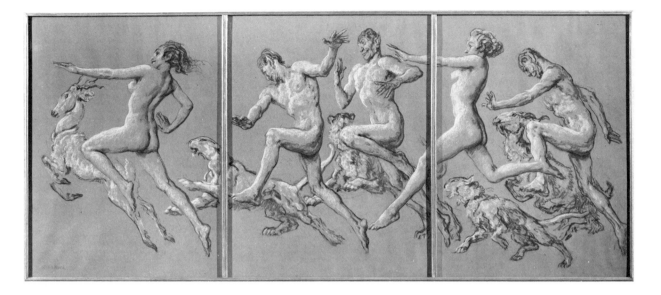

FRANCIS LUIS MORA (1874-1940)

56. Woodland Carnival: A Triptych

Charcoal and yellow chalk on brown paper, left panel: 25¾ × 19¼ in., center panel: 25¾ × 20¹⁄₁₆ in., right panel: 25¾ × 18⅞ in.

Signed (at lower left): F. Luis Mora.

Executed about 1910-20

Born in Montevideo, Uruguay, Mora studied art at the School of the Museum of Fine Arts, Boston, Massachusetts, under Edmund Tarbell and Frank Benson, and later at the Art Students League, New York, under H. Siddons Mowbray. In 1894 he visited Spain where he began to paint scenes of Spanish life, and throughout his career continued to explore both realistic and allegorical subjects.

As is evident in this fanciful triptych, Mora was an extremely skillful draughtsman. With this proficiency and a firm understanding of anatomy he was able to infuse even his most whimsical characters with tremendous vitality and spirit. Mora's curious allusion to paganism— the quirky sexual habits of satyrs and nymphs, revived in various forms during the American Renaissance—is here given comic contemporaneity.

HENRY SIDDONS MOWBRAY (1858-1928)

57. Study for Ceiling of the Gunn Memorial Library, Washington, Connecticut

Oil on canvas, 48 × 25 in.

Painted in 1914

RECORDED: Letters, Rawson W. Haddon, Director, Mattatuck Historical Society, Waterbury, Connecticut, to Henry S. Mowbray, Jan. 13 & 14, 1966 (mss., archives, Mattatuck Historical Society) // National Collection of Fine Arts, Smithsonian Institution, Washington, D.C., *Artist Index: Inventory of American Paintings* (Dec. 20, 1977), p. 126 no. 07770104

EXHIBITED: The Brooklyn Museum, New York, National Collection of Fine Arts, Smithsonian Institution, Washington, D.C., The M. H. de Young Memorial Art Museum, San Francisco, California, and The Denver Art Museum, Colorado, 1979-80, *The American Renaissance: 1876-1917*, pp. 182 fig. 153, 183, 187, 224 no. 220

EX COLL.: the artist; to his son, Henry S. Mowbray, Washington, Connecticut, 1928-66; by gift to the Mattatuck Historical Society, Waterbury, Connecticut, 1966-77; to [sale, Robert Glass Auction Gallery, Central Village, Connecticut, May 5, 1977]; [sale, Parke-Bernet, New York, April 20, 1979, no. 114]; to Henry D. Ostberg, New York, 1979-85

Inspired by the revival of mural painting in France, many American art students, returning to the United States during the late 1870's and 1880's, believed this métier to be a viable artistic endeavor. H. Siddons Mowbray and many of his contemporaries—Kenyon Cox, Edwin Blashfield, Will H. Low, among others—not only predicted an optimistic future for mural painting in the United States but devoted the better part of their careers to its fruition. Though Mowbray painted easel pictures during the 1880's and 1890's (no. 58), by the 1890's his primary occupation was with decorative work. Although recognized and patronized by the noted American collectors Thomas B. Clark and William T. Evans, Mowbray became increasingly dissatisfied with easel painting. He wrote:

". . . I was tired of the photographic realism of the school in which I had been educated and its blighting dependence on the model for everything. I wanted above all things to do mural work" [Herbert F. Sherwood, ed., *H. Siddons Mowbray: Mural Painter* (1928), p. 56; reprinted in Gwendolyn Owens, "H. Siddons Mowbray: Easel Painter," in *Art & Antiques*, III (July-Aug. 1980), p. 86]. Mowbray's confession reveals not only his desire to practice mural painting, but his admiration for Italian Renaissance art. Even more than some of his colleagues, who also had studied the work of Italian fresco painters firsthand, Mowbray consciously set out to emulate the salient characteristics of Pinturicchio and other fifteenth century masters.

In 1898 Mowbray moved to Washington, Connecticut, where, in 1914, he was commissioned to paint a ceiling for the town's Gunn Memorial Library. Recalling his 1897 mural program for the Vanderbilt mansion in Hyde Park, New York, he depicted scenes from Greek mythology. Carefully designed and highly finished, his decorative programs were often realized first on the scale of this study, then squared-off and transferred to canvases measuring the exact sizes of the individual spaces. Stylistically, this program reflects an assimilation of fifteenth century Italian Renaissance models.

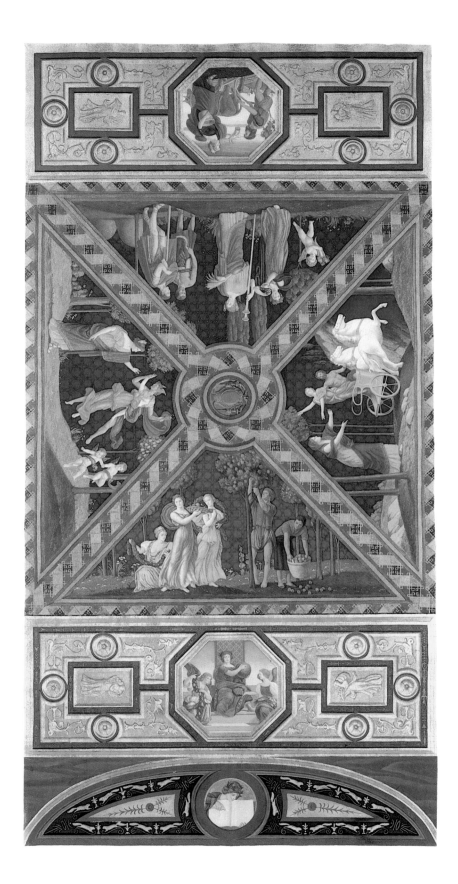

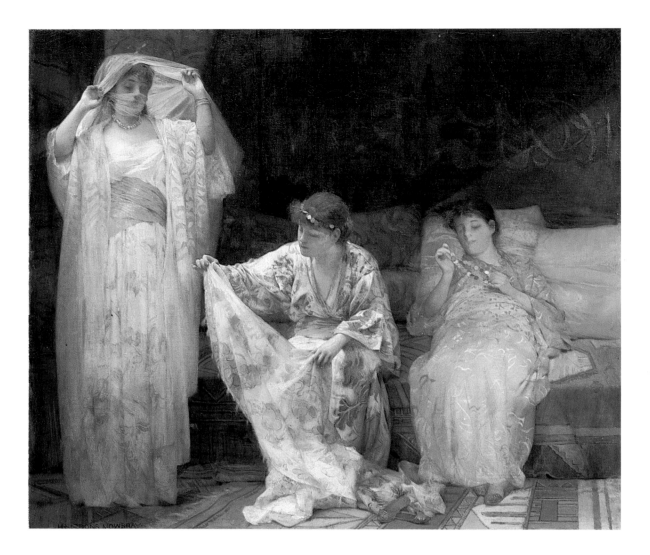

HENRY SIDDONS MOWBRAY (1858-1928)

58. The Harem

Oil on canvas, 12½ × 14½ in.

Signed (at lower left): H. SIDDONS MOWBRAY

Painted about 1885

Mowbray's commitment to mural painting after 1900 in
no way lessens the significance of his smaller easel pic-
tures. Initially inspired by Jean-Léon Gérôme's exotic
depictions of the Near East, Mowbray adapted similar
subject matter and Gérôme's academic realism for his own
work. *The Harem* relates to such other pictures by
Mowbray as *Idle Hours* (National Museum of American
Art, Washington, D.C.) and *Roses* (National Academy of
Design, New York), in which two or more female figures,
dressed and adorned with Near Eastern robes and jew-
elry, populate intimate interiors. Exotic genre painting
during the American Renaissance created images outside
the classic mainstream of western art, and generated
new iconography by using contemporary female models
whose attitudes suggest a luxurious, exotic life of lei-
sure and fantasy.

WILLIAM ORDWAY PARTRIDGE (1861-1930)

59. Homer Reciting the "Iliad"

Bronze, greenish-brown patina, 14¼ in. high ×
42⅜ in. wide × 21½ in. deep

Signed and dated (on proper left side): Partridge 1900

Founder's mark (on the base): ROMAN BRONZE
WORKS N.Y.

RECORDED: cf. Marjorie Pingel Balge, *William Ordway
Partridge (1861-1930): American Art Critic and Sculptor*
(Ph.D. dissertation, 1982, University of Delaware, New-
ark; University Microfilms, 1982), p. 245 no. 74 illus., as
Homer Group, 1902

Ancient literary themes were an important source of
inspiration to artists of the American Renaissance. In
depicting the great Greek poet Homer reciting his *Iliad*
to a classically-garbed group of listeners, Partridge has
given us his homage to ancient civilization, translated,
perhaps, through such Italian Renaissance models as
Raphael's *School of Athens* (Vatican Palace, Rome). The
decorative detail of the exedra setting reflects the contem-
porary Beaux-Arts style, but ultimately recalls ancient
architectural models.

According to Marjorie Pingel Balge [*loc. cit*], *Homer Recit-
ing the "Iliad"* (or the *Homer Group*) was originally
commissioned for the library of P. A. Valentine of New
York. The Valentine work, executed in marble and bronze,
size unknown, is currently unlocated. Balge also cites
two replicas, executed before 1908 (both, marble and
bronze, sizes and locations currently unknown), one of
which was originally in the collection of Lewis Stern, Hyde
Park, London, England, and the other, in the collection
of Spencer Trask, Saratoga Springs, New York.

Homer Reciting the "Iliad" relates in composition to
Partridge's *Kauffman Memorial*, Rock Creek Cemetery,
Washington, D.C., of 1897, a simplified exedra configura-
tion, with a single figure and less embellished architec-
tural setting.

Because of the date of the present work and its single
medium, it may be the preliminary working model for the
Valentine commission.

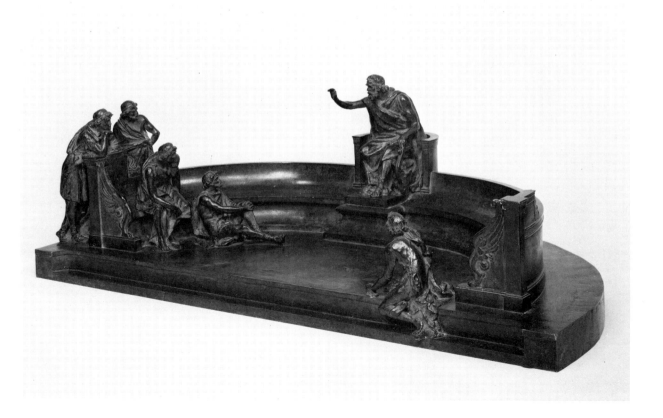

JANE PETERSON (1876-1965)

60. Low Library, Columbia University

Gouache and charcoal on paper, 17¼ × 23⅛ in.

Signed (at lower right): Jane Peterson

Painted about 1925

EXHIBITED: Hirschl & Adler Galleries, New York, 1970, *Jane Peterson: A Retrospective Exhibition*, [n.p.] no. 36 // Santa Fe East, New Mexico, 1982, *Five American Women Impressionists*, pp. 26 illus., 38 [n.n.]

Peterson's career was distinguished by a long and productive life, an extensive art education, and a vivacious spirit always in search of new experiences. Though she was introduced to modern European art by 1908, in her own work Peterson remained loyal to figuration and naturalism.

Designed by the architectural firm of McKim, Mead, and White, the Low Library at Columbia University, New York, was constructed between 1895 and 1897. Peterson's depiction of this Beaux-Arts edifice was consistent with her formal inclinations and stylistic diversity. Her execution of the library's facade, with its Ionic colonnade, entablature, and massive rotunda, embodies a broad treatment, simplified but sculpturesque, and reflects her knowledge of French post-impressionist painters, in particular Pierre Bonnard, André Derain, and André L'hote. *Low Library* is Peterson's tribute to the grand tradition of the American Renaissance.

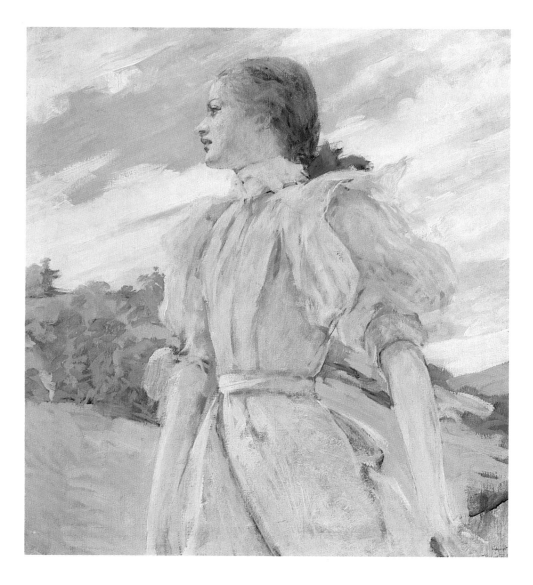

ROBERT REID (1863-1929)

61. A Breezy Day

Oil on canvas, 37¼ × 33¾ in.

Signed and inscribed (at lower right): Copyright/Robert Reid

Painted about 1898

RECORDED: Letter, The Art Committee to Mr. Chauncey J. Hamlin, Oct. 14, 1920 (ms., Registrar's Office, Albright-Knox Art Gallery, Buffalo, New York) // Cornelia B. Sage Quinton, "Report of the Art Director for the Year 1920 / . . . / Acquisitions / . . . / Gifts," in *The Buffalo Fine Arts Academy/Albright Art Gallery/The Academy Blue Book* (1922), p. 31

EXHIBITED: Music Hall and Coliseum Building, The St. Louis Exposition and Music Hall Association, Missouri, 1898, *15th Annual Exhibition*, p. 110 no. 382

EX COLL.: the artist, in 1898; Mr. and Mrs. Chauncey J. Hamlin, Buffalo, New York, by 1920; by gift to the Buffalo Fine Arts Academy, Albright Art Gallery, 1920-61; returned to the daughter of the donors, 1961-83

Reid's Parisian training in the Académie Julian during the 1880's, coupled with his adaptation of an impressionistic palette, produced a style concerned with form but sensitive to transient effects of natural light. In *A Breezy Day* Reid gave traditional figure painting a fresh veneer. Posing his model outside in a light-filled landscape, he endowed her with monumentality through a consciously controlled bravura. Reid's assimilation of French Impressionism was tempered by his academic training and his desire to combine this European discovery with distinctly American attitudes. *A Breezy Day*, like *The Five Senses* (nos. 62a-e), elevated contemporary American women to cultural icons, but in doing so avoided the timeless idealizations reserved for goddesses and nymphs.

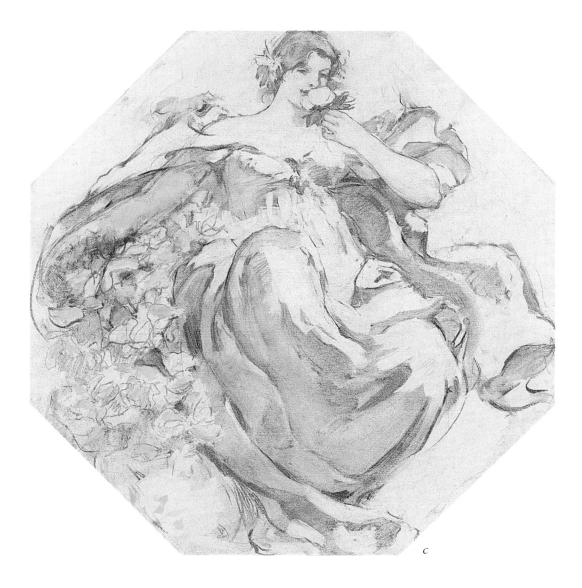

c

ROBERT REID (1863-1929)

62. The Five Senses

a) Study for "Taste"
b) Study for "Hearing"
c) Study for "Smell"
d) Study for "Touch"
e) Study for "Sight"

a), b), d), e): each, charcoal with colored chalk on canvas, 23¾ × 23¾ in. (hexagonal); c): charcoal with colored chalk and oil on canvas, 23¾ × 23¾ in. (hexagonal)

Executed by 1896

RECORDED: *cf.* Herbert Small, ed., *Handbook of the New Library of Congress* (1897), pp. 46-48 finished versions of *Touch* and *Hearing* illus. // *cf.* William A. Coffin, "The Decorations in the New Congressional Library," in *The Century*, LIII (March 1897), pp. 702 finished version of *Hearing* illus., 703 finished version of *Touch* illus., 709 // *cf.* Pauline King, *American Mural Painting* (1902), pp. 202 finished versions of each illus., 203 // *cf.* Trudy Baltz, "Pageantry and Mural Painting," in *Winterthur Portfolio*, XV (1980), p. 275 fig. 20

EXHIBITED: Hirschl & Adler Galleries, New York, 1982-83, *Lines of Different Character*, pp. 66-67 nos. 50a illus., 50b illus., 50c illus. in color, 50d illus., 50e illus.

Robert Reid was among the many American artists selected to decorate various parts of the new Library of Congress, Washington, D.C., originally chartered by an act of Congress in April 1886. These five pictures are "cartoons" for the series titled *The Five Senses*, completed in 1896.

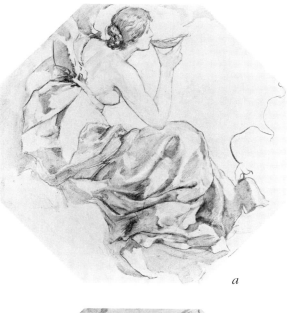

a

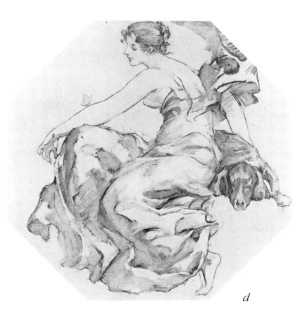

d

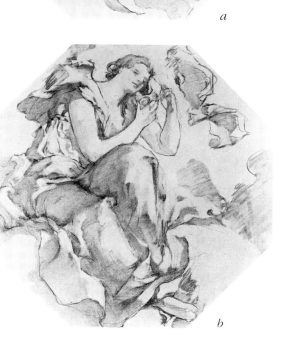

b

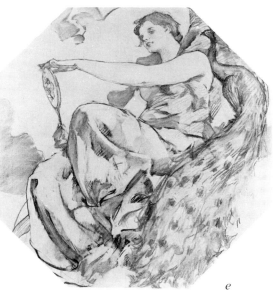

e

The five finished panels are located on the vaulted ceiling of the north corridor of the Library, together with four rondels, also by Reid, depicting *Poetry*, *Prose*, *History*, and *Science*, on the walls of the same area. Of Reid's program, William Coffin [*loc. cit.*] noted: "Each of the nine spaces contains a single draped female figure The lines of the figures are graceful, and the faces are good expressions of the decorative scheme—to represent each subject by a figure of a young and beautiful woman, to rely in the interpretations on natural beauty without classic convention, and to obtain grace of movement as the chief point in the different arrangements."

Several years later, Pauline King [*loc. cit.*] elaborated:

. . . Reid's five octagons in the ceiling show *The Senses*, under the guise of graceful young women, with slender figures and long limbs. Their pretty faces are distinctly modern in type, and their carelessly arranged draperies suggest very aesthetic negligées.

They lounge in easy attitudes: *Taste* drinking from a shell; *Sight* gazing at her image in a small mirror, a peacock, whose great tail falls to her feet, preening himself over her shoulder; *Smell*, a luxuriant beauty resting by a bank of lilies and roses, her face half buried in a large flower, another in her hair showing coquettishly behind her ear; *Hearing*, listening to the sound held in a sea-shell; and *Feeling*, watching a butterfly flit delicately along her extended arm.

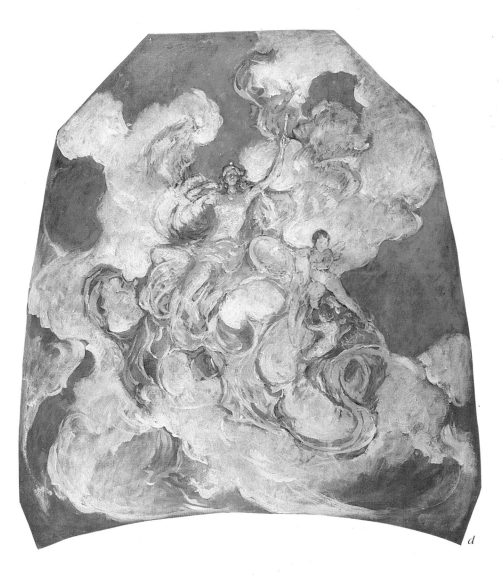

d

ROBERT REID (1863-1929)

63. The Abundance of California: Oil Sketches for Murals at the Palace of Fine Arts, Panama-Pacific International Exposition, San Francisco

 a) Birth of European Art
 b) Inspiration of All Arts
 c) The Golden Fruit
 d) The Golden Metal
 e) The Golden Poppy

Each, oil on canvas, 54 × 48 in.

Painted about 1914

RECORDED: *cf.* Eugene Neuhaus, *The Art of the Exposition, Personal Impressions of the Architecture, Sculpture, Mural Decorations, Color Scheme and Other Aesthetic Aspects of the Panama-Pacific International Exposition* (1915), pp. 54-57, 83 // *cf.* Christian Brinton, *Impressions of the Art at the Panama-Pacific Expositions* (1916), p. 48 // *cf.* Hamilton Wright, "Mural Decorations at the Panama-

Pacific International Exposition," in *Art in California* (1916), pp. 137-38 // *cf.* Edward Simmons, *From Seven to Seventy* (1922), p. 339

EXHIBITED: Utah Museum of Fine Arts, University of Utah, Salt Lake City, 1977, *Mural Sketches and Impressionist Paintings by Robert Reid*, nos. 16, 18, 19, 20, 22

EX COLL.: Mr. and Mrs. Ken Garff, Mr. and Mrs. Robert Garff, and Mr. and Mrs. Gary Garff, Salt Lake City, Utah, until 1975; by gift to the Utah Museum of Fine Arts, University of Utah, Salt Lake City, until 1985

Organized to celebrate the opening of the Panama Canal, the Panama-Pacific International Exposition of 1915 was perhaps the largest world's fair in the United States since the World's Columbian Exposition, Chicago, Illinois, of 1893. A vast complex of buildings, ornamental gateways, and pavilions was erected at the fair site along the San Francisco Bay. Designed by a variety of noted architects, these structures were adorned with sculpture and mural

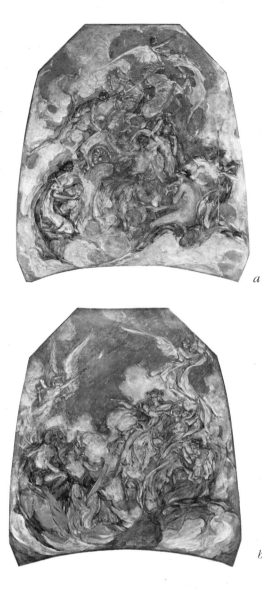

a

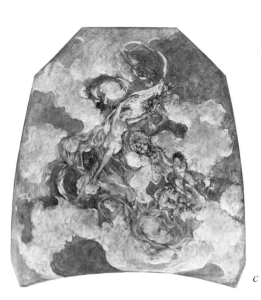

c

b

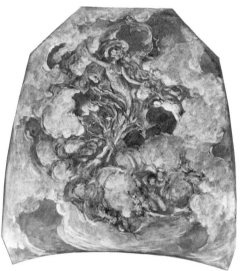

e

decorations specifically commissioned for the exposition. Among the American painters who contributed to the mural decoration of the buildings were three important members of "The Ten," Childe Hassam, Edward Simmons, and Robert Reid.

Reid was equally famous for his mural decorations as for his brilliant impressionistic canvases. The present oil paintings are five of the studies for a group of eight murals that Reid executed for the Panama-Pacific International Exposition. The actual murals, believed to be still owned by the City of San Francisco, are irregularly shaped canvases measuring approximately twenty-seven by twenty-three feet. They were designed to be fitted into the dome of the rotunda which stood in front of the Palace of the Fine Arts, built under the plans of architect Bernard Maybeck. The theme of the murals was a salute to the abundance of California. Four of the panels described the "Golds of California": the golden poppy, grain, fruit, and metal; and four panels represented the "Golden Arts of

California": European Art, Oriental Art, ideals in art, and inspiration in all arts. Although the oil sketches are less finished than the actual murals, in conception and effect they are close to the completed decorations, which, suspended high above the viewers' heads, were described by Hamilton Wright [*loc. cit.*] as "…almost indescribable bits of color, with traceries as delicate as the weavings of a spider's web, and designs as fantastic as, but far more beautiful than those ever executed by the most cunning of the ancient Chinese goldsmiths."

While Reid had always been a muralist with a heightened concern for pattern and design, his California panels suggest an even further step towards abstraction by their creation of intricate mosaics of light and color. These oil sketches vividly represent the decorative impressionist spirit of Reid's mural work.

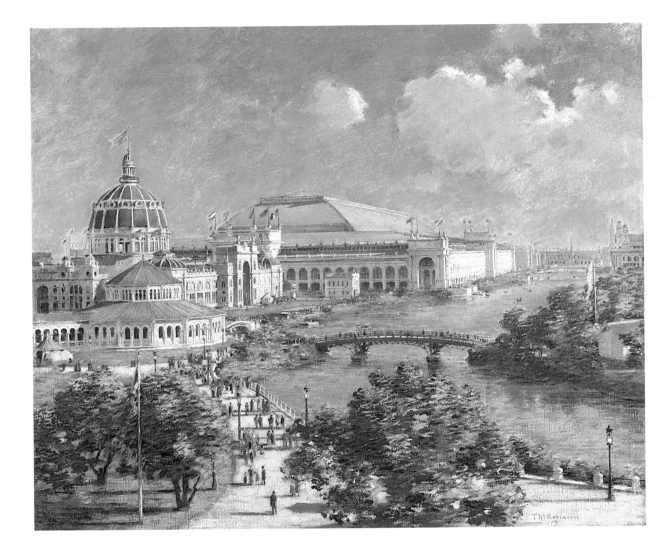

THEODORE ROBINSON (1852-1896)

64. World's Columbian Exposition, Chicago, Illinois

Oil on canvas, 25 × 30 in.

Signed (at lower right): Th. Robinson

Painted in 1894

RECORDED: Theodore Robinson, "Diary II" (ms., Frick Art Reference Library, New York), [n.p.] entries for March 12, 23, 31, April 25, 29, May 14, 31, 1894 // John I. H. Baur, *Theodore Robinson 1852-1896* (1946), pp. 38, 94 as *World's Fair View* (among "unidentified works") // William H. Gerdts, *American Impressionism* (1984), p. 140 colorpl. 147

EXHIBITED: Whitney Museum of American Art, New York, The St. Louis Art Museum, Missouri, Seattle Art Museum, Washington, and The Oakland Museum, California, 1977-78, *Turn-of-the-Century America: Paintings, Graphics, Photographs, 1890-1910*, pp. 72 colorpl. V, 73, 191, as *Columbian Exposition* // Museum of Fine Arts, Boston, Massachusetts, The Corcoran Gallery of Art, Washington, D.C., and the Grand Palais, Paris, France, 1983-84, *A New World: Masterpieces of American Painting 1760-1910*, pp. 170 colorpl. 95, 319-20 no. 95 illus.

EX COLL.: [art market, New York, 1899]; to William H. Perkins, New York; by gift to the Spalding Memorial Library, Athens, Pennsylvania, 1899-1977; to [Jeffrey R. Brown, Massachusetts, 1977]; to private collection, 1977-79; to [Hirschl & Adler Galleries, New York, 1979-80]; to private collection

Theodore Robinson executed two paintings of the 1893 World's Columbian Exposition, Chicago, Illinois, for a pro-jected commemorative album that Francis D. Millet and Daniel Burnham, Directors of Decoration and Works for the fair, were compiling on the "White City." Based upon a photograph taken by Charles Dudley Arnold [*cf.* Stanley Appelbaum, *The Chicago World's Fair of 1893: A Photographic Record* (1980), p. 72 no. 89 illus.], head of the fair's Bureau of Photography, this painting appears never to have been used for lithographic reproduction. It would seem to be the second of Robinson's paintings of the subject, as described in his "Diary II" [*op. cit.*, entry for March 12, 1894] as "a big world's fair canvas, for colored plate 25 × 30″."

Apparently remaining with Robinson until his death, the picture was on the art market in 1899. It was purchased by William H. Perkins, President and Director of the Bank of America, specifically to donate to the Spalding Memorial Library, Athens, Pennsylvania, the city where his parents resided. The painting was one of six that Perkins gave to the library in 1899 with the hope that they would form the nucleus of a valuable art collection.

World's Columbian Exposition is a dazzling impressionist work. It also serves as an important visual document of perhaps the greatest collaborative artistic effort of the American Renaissance. The view in Robinson's painting, looking southward, takes in the east bank of the lagoon, which formed the central axis of the fairgrounds. The Fisheries Building, designed by the Chicago architect Henry Ives Cobb, is to the left; behind it is the United States Government Building, which the official Treasury Department architect, Willoughby J. Elbrooke, had designed. The Colonnade and Obelisk, created by the Boston, Massachusetts, firm of Peabody and Stearns, can be seen in the distance.

Private collection

AUGUSTUS SAINT-GAUDENS (1848-1907)

65. Robert Louis Stevenson

Bronze relief, dark brown patina, 17⅜ × 24 in.

Signed, dated, and inscribed (at upper right): · TO ·
MARIA · OAKEY · DEWING · / · AVGVSTVS · SAINT-GAV-
DENS · / · ASPET · M · C · M · V · [1905]; inscribed (across the
top): · ROBERT · LOVIS · STEVENSON · M · D · C · C · C · L ·
XXX · VII · [1887]/ · BRIGHT · IS · THE · RING · OF · WORDS ·
WHEN · THE · RIGHT · MAN · RINGS · THEM · / · FAIR ·
THE · FALL · OF · SONGS · WHEN · THE · SINGER · SINGS ·
THEM · / · STILL · THEY · ARE · CAROLLED · AND · SAID ·
ON · WINGS · THEY · ARE · CARRIED · / · AFTER · THE ·
SINGER · IS · DEAD · AND · THE · MAKER · BVRIED ·

Model executed about 1900

RECORDED: Letter, Maria Oakey Dewing to Augustus
Saint-Gaudens, Oct. 7, 1905 [?] (ms., Saint-Gaudens Papers,
Dartmouth College, Hanover, New Hampshire, Reel 5,
Frames 506-14) // cf. John H. Dryfhout, *The Work of
Augustus Saint-Gaudens* (1982), pp. 261-63 no. 188,
another bronze illus. p. 263 no. 188-7

EX COLL.: the sculptor; to Maria Oakey Dewing, in 1905; by
descent in her family, until 1985

In 1894 Saint-Gaudens was commissioned to create a
memorial to his friend, the poet and author Robert Louis
Stevenson (1850-1894), for the Church of St. Giles, Edin-
burgh, Scotland. Completed in 1903, the large relief, rec-
tangular in format and measuring 91 × 109 inches, is a
variant on Saint-Gaudens' 1887 design of the same subject.

Reductions of the work were cast after 1900. In addition to
the present relief, which bears a personal dedication to
Saint-Gaudens' friend, the painter Maria Oakey Dewing,
who was the wife of Thomas Wilmer Dewing (nos. 13-16),
nine bronzes and two plasters are known to exist. Only
one other, a plaster in the collection of the Beinecke
Library, Yale University, New Haven, Connecticut, bears a
personal inscription [to Jeannette L. Gilder, from Saint-
Gaudens' son Homer]. There is another plaster in the

collection of the Saint-Gaudens National Historic Site,
Cornish, New Hampshire, which also has a bronze. Other
bronzes are in the Museum of Art, Carnegie Institute,
Pittsburgh, Pennsylvania, the Hood Museum of Art,
Dartmouth College, Hanover, New Hampshire, Houghton
Library, Harvard University, Cambridge, Massachusetts,
R. W. Norton Gallery, Shreveport, Louisiana, Silverado
Museum, St. Helena, California, and three in private
collections.

In a letter dated October 7th [1905?], Maria Dewing wrote
[*loc. cit.*] to Saint-Gaudens about the present relief:

> The Stevenson is superb in the bronze & my name
> placed by yr own in that finely modelled background
> pleased me greatly—

> The modelling of the background I never appreci-
> ated in the plaster cast that I am familiar with. It shows
> to great advantage in the bronze.

> The very beautiful detail of the garland has a great
> fascination for me. I have for years said so much about
> the figure with the subtle movement of the hands
> that it is only left for me to speak of the surprizes the
> bronze has revealed to me.

> I wish I knew if any other of the Stevensons has
> [illeg.] the [illeg.] I chose. It seemed so very apt there
> & [I] am wondering if mine is unique in this particu-
> lar. . . .

AUGUSTUS SAINT-GAUDENS (1848-1907)

66. Victory

Gilded bronze, 42½ in. high

Signed, dated, and inscribed (on the base): AVGVSTVS
SAINT GAVDENS/FECIT MCMII [1902]

Founder's stamp (on the base): GORHAM CO FOUNDERS

RECORDED: John H. Dryfhout, *The Work of Augustus
Saint-Gaudens* (1982), p. 256, as in the collection of
J. J. Thompson, another example illus.

EXHIBITED: Hirschl & Adler Galleries, New York, 1984,
The Art of Collecting, pp. 44-45 no. 32 illus. in color

EX COLL.: Homer Saint-Gaudens, the artist's son, Pitts-
burgh, Pennsylvania, and Florida; J. J. Thompson, Fort
Lauderdale, Florida; to the estate of J. J. Thompson, until
1983; to [Hirschl & Adler Galleries, New York]; to private
collection, 1984-85

This bronze is a reduction of the monumental allegorical
figure of "Victory" in the equestrian grouping titled the
Sherman Monument, Grand Army Plaza, 59th Street and
Fifth Avenue, New York. Saint-Gaudens began working on
the monument in his New York studio in 1892, con-
tinued work in Paris, and finally completed it at his Cor-
nish, New Hampshire, studio in 1903.

Saint-Gaudens is said to have expressed regret that he did
not have more opportunity to create purely idealized
images in his work. From his early success with the
Farragut Monument of 1877-80 (Madison Square Park,
New York), he became so occupied with commissions that
he often strove in these works to combine the real with
the ideal in order to satisfy his own sense of idealized
beauty. One of his most successful images, where the
literal and the symbolic are forcefully interwoven, is the
Sherman Monument. In it, the carefully studied eques-
trian portrait of General William Tecumseh Sherman is

contrasted with the allegorical figure of "Victory," who,
according to John Wilmerding, "draws her inspiration
from such powerful historical models as the Hellenistic
Nike of Samothrace and Delacroix's *Liberty at the Bar-
ricades,* both of which were accessible to Saint-Gaudens at
the Louvre." Wilmerding continued: "She appears in his
work under many guises and in differing scale, from Lib-
erty on the 1907 gold coin to the full-sized relief of *Amor
Caritas*" [Foreword, from Dryfhout, *op. cit.*, p. xi].

Nine reductions of the *Victory*, probably cast in bronze
after 1912, are known to exist, and are in the following
collections: The Metropolitan Museum of Art, New York,
Museum of Art, Carnegie Institute, Pittsburgh, Pennsylva-
nia, Arlington National Cemetery, Virginia, the Univer-
sity of Delaware, Newark, the Saint-Gaudens National
Historic Site, Cornish, New Hampshire, which also has the
plaster model, Mr. and Mrs. Erving Wolf, New York, and
two in private collections.

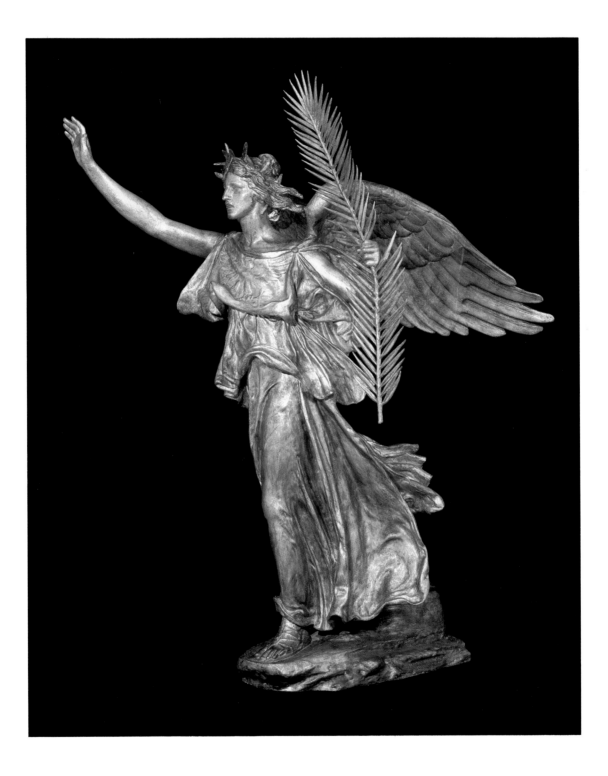

AUGUSTUS SAINT-GAUDENS (1848-1907)

67. Head of "Victory"

Gilded bronze, 8⅛ in. high (excluding marble base)

Inscribed (on the front): NIKH-EIPHNH (Nike-Eirene [Peace-Victory])

Model executed about 1902-03

RECORDED: John H. Dryfhout, *The Work of Augustus Saint-Gaudens* (1982), pp. 257-58 no. 185, as in a private collection, Port Clyde, Maine, another example illus.

EX COLL.: the sculptor; to his friends, Mr. and Mrs. Charles Fairchild, Boston, Massachusetts, and Newport, Rhode Island; by descent in the Fairchild family, until 1984

This bronze is Saint-Gaudens' second study for the head of his allegorical figure of *Victory* (no. 66) in the eques-trian monument to General William Tecumseh Sherman at Grand Army Plaza, Fifth Avenue and 59th Street, New York. Although the sculptor is said to have preferred this model, he felt his earlier study was better suited to the monument and ultimately reworked it for the finished statue. This second version later served as the model for the profile reliefs in Saint-Gaudens' new penny and his ten dollar coin.

Other castings are in the collections of The Metropolitan Museum of Art, New York, The Newark Museum, New Jersey, the Saint-Gaudens National Historic Site, Cornish, New Hampshire, the Museum of Fine Arts, Boston, Massachusetts (two copies), the St. Louis Art Museum, Missouri, and the Rose Nichols House, Boston, Massachusetts. The National Museum of American Art, Smithsonian Institution, Washington, D.C., has a plaster model for this head.

ROBERT VAN VORST SEWELL (1860-1924)

68. Psyche's Wanderings

Oil on canvas, 32⅛ × 64¼ in. (arched top)

Signed and dated (at lower right): .R V V. SEWELL 1901

RECORDED: Arthur C. David, "The St. Regis—The Best Type of Metropolitan Hotel," in *The Architectural Record*, XV (June 1904), pp. 586, 593, *cf.* illus. pp. 581, 584 // William Laurel Harris, "Mural Painting in the United States," in *American Art Annual*, IX (1911), p. 25, as *The Story of Psyche* // "Vincent Astor Sells St. Regis to B. N. Duke," in the New York *Herald-Tribune*, Feb. 5, 1927, as *The Story of Psyche*

EXHIBITED: Central Pavilion, The Art Palace, St. Louis, Missouri, 1904, *Universal Exposition*, p. 42 no. 992

EX COLL.: St. Regis Hotel, New York, 1904-27

Sewell drew most of his subjects from allegorical, mythological, and literary sources. The story of Psyche, for example, is told in the *Golden Ass* by the ancient Latin writer Apuleius. Sewell was commissioned to do a series of seven large-scale paintings, of which the present work is one, illustrating scenes from this legend. The paintings were first exhibited at the 1904 Universal Exposition, St. Louis, Missouri, organized to commemorate the

one-hundredth anniversary of the Louisiana Purchase. After the Exposition the seven panels were installed in the Palm Room of the St. Regis Hotel, New York. The hotel, built in 1904 by Vincent Astor and designed by the firm of Trowbridge & Livingston, was lavishly decorated by artists of the American Renaissance period, including Louis Comfort Tiffany, who created the Palm Room's ceiling. In 1927, when Vincent Astor sold the hotel to B. N. Duke, the ground floor was remodeled and much of the interior decoration was lost.

This painting depicts Psyche wandering in a barren landscape to appease the jealous Venus. The present location of the other six paintings is unknown.

EVERETT SHINN
99

EVERETT SHINN (1873-1953)

69. Madison Square and the Dewey Arch: Cross Streets of New York

Pastel, gouache, and watercolor on board, 29 × 18 in. (sight size)

Signed and dated (at lower center): EVERETT SHINN/99

RECORDED: Jesse Lynch Williams, "The Cross Streets of New York," in *Scribner's Magazine*, XXVII (Nov. 1900), p. 582 illus.

Along with George Luks, William Glackens, and John Sloan, Shinn began his artistic career during the 1890's as a newspaper illustrator in Philadelphia, Pennsylvania. He moved to New York in 1897 and continued working as an illustrator, first for the *New York World* and later for various magazines including *Harper's* and *Vanity Fair*. As part of a particular assignment he would often submit colored drawings to accompany the text for a story. These were sometimes executed in pastel. Although he had not worked in pastel since his student days at the Pennsylvania Academy of the Fine Arts, Philadelphia, he quickly mastered the medium. Between 1898 and 1899 he completed over fifty pastels that were exhibited in 1900 at the Pennsylvania Academy. Executed in mixed media, *Madison Square and the Dewey Arch* was published in *Scribner's Magazine*, XXVII (Nov. 1900), p. 582, to accompany Jesse Lynch Williams' "The Cross Streets of New York."

During the Spanish-American War of 1898, Admiral George Dewey was sent to the Phillipines to defeat the Spanish navy in Manila Bay. To commemorate his success, the Dewey Victory Arch, designed by Charles R. Lamb (1863-1928)—architect and partner of J. and R. Lamb Studios, specialists in ecclesiastical decorative art—was constructed at Madison Square, New York, on Fifth Avenue, between 24th and 25th Streets. As part of an elaborate architectural and sculptural program, eminent contemporary sculptors, including John Quincy Adams Ward, Daniel Chester French, and Karl Bitter, created sculptural groups to adorn this triumphal arch, and the entire landmark was unveiled during the victory celebrations of 1899. Hastily constructed in six weeks, the arch—composed of staff (plaster reinforced with hay or burlap fiber)—was demolished in 1900. Shinn's drawing is a visual document of this short-lived but significant architectural monument of the American Renaissance.

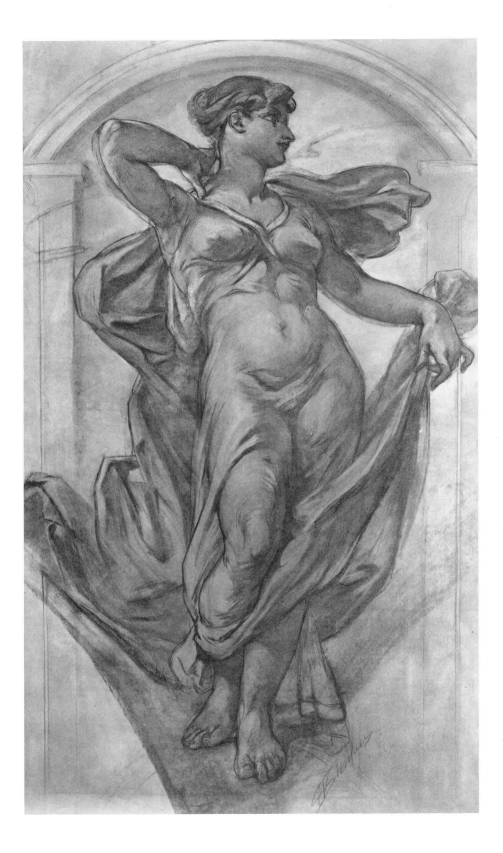

WALTER SHIRLAW (1838-1909)

70. Study for "Gold"

Charcoal and pastel on tan paper, 54 × 31 in.

Signed (at lower right): W Shirlaw

Executed about 1892

RECORDED: *cf.* Pauline King, *American Mural Painting* (1902), pp. 70, 74-75

EXHIBITED: *cf.* Carnegie Institute, Pittsburgh, Pennsylvania, 1911, *Memorial Exhibition of Paintings and Drawings by Walter Shirlaw, N.A.*, [n.p.] no. 263, as *Design for Dome, Columbian Exposition, Chicago*

Shirlaw began his career as an engraver. In 1870 he traveled abroad and studied in Munich, Germany, for about seven years. His return to America in 1877 corresponded with the formation of the Society of American Artists; his direct involvement led to his election as its first president. Until his death, he remained active in the New York art community, teaching and painting easel pictures and monumental murals.

For the Manufactures and Liberal Arts Building at the 1893 World's Columbian Exposition, Chicago, Illinois, Shirlaw executed four murals illustrating *The Abundance of Land and Sea*. *Study for "Gold"* is a life-size cartoon for one of these murals. About Shirlaw's program, Pauline King [*loc. cit.*] wrote:

. . . Mr. Shirlaw, in setting forth *The Abundance of Land and Sea,* covered his entire space with a great spider web, with *Silver* and *Gold* poised in the pentatives [sic] on great nuggets of precious metal. They were clad appropriately in yellow and in silver grey, while in the opposite corners *Pearl* standing on an oyster shell was adorned with glistening strings of pearls, and *Coral* was decking her hair with a red ornament.

Artists who painted murals for the Manufactures and Liberal Arts Building were given a plaster model of the dome to facilitate their final conception. In *Study for "Gold,"* Shirlaw took into consideration perspectival distance and foreshortening, and suggested the arched niche that would enframe his allegorical figure positioned in one of the pendentives of the Beaux-Arts dome.

a

b

WALTER SHIRLAW (1838-1909)

71a. Electricity

Pastel on paper, 10 × 7¾ in.

Inscribed (on the back): Electricity Design/Walter Shirlaw

Executed about 1900-10

EXHIBITED: Hirschl & Adler Galleries, New York, 1979, *American Drawings and Watercolors*, [n.p.] no. 99a

This group of sketches represents the conceptual basis of a mural project, as yet unidentified. As with *Study for "Gold"* (no. 70) and the series based on the *Sciences* for the Library of Congress, Washington, D.C. (1896-97), Shirlaw drew personifications (in this case male) to symbolize the material progress of culture. *Electricity*, animated in the foreground, wields wire on a pole; an electrical plant is suggested in the background. *Commerce*, contemplative, with one elbow resting on a classical pediment, steadies a wheel in one hand; another factory in the background reinforces the idea. *Industry* wears the cap of Thor and holds thunder bolts, symbols of the power that generates production. *Transportation*, personified by Mercury, the messenger God, wears winged sandals and is poised on one foot while balancing his winged wheel.

71b. Industry

Pastel on paper, 8½ × 5 in.

Executed about 1900-10

EXHIBITED: Hirschl & Adler Galleries, New York, 1979, *American Drawings and Watercolors*, [n.p.] no. 99d

c

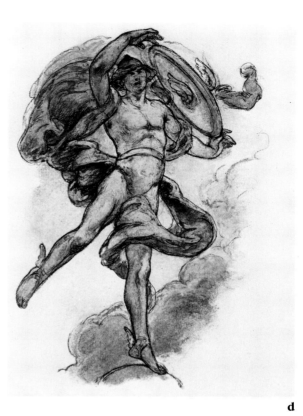

d

71c. Commerce

Pastel on paper, 9⅞ × 7¾ in.

Inscribed (on the back): Commerce Design Walter Shirlaw N.A.

Executed about 1900-10

EXHIBITED: Hirschl & Adler Galleries, New York, 1979, *American Drawings and Watercolors*, [n.p.] no. 99b

71d. Transportation

Pastel on paper, 9⅞ × 7⅝ in.

Inscribed (on the back): Transportation Design Walter Shirlaw N.A.

Executed about 1900-10

EXHIBITED: Hirschl & Adler Galleries, New York, 1979, *American Drawings and Watercolors*, [n.p.] no. 99c

FRANKLIN SIMMONS (1839-1913)

72. Penelope

Marble, 36½ in. high × 17 in. wide × 28½ in. deep

Signed, dated, and inscribed (on the base): FRANKLIN SIMMONS/ROME 1908

Model executed about 1880

RECORDED: *cf.* Wayne Craven, *Sculpture in America* (1968), pp. 297, 310 fig. 8.19 // *cf.* Whitney Museum of American Art, New York, *200 Years of American Sculpture* (1976), pp. 44 fig. 54, 309, 346 no. 245

As told in Homer's *Odyssey,* Penelope, the wife of Ulysses, was separated from her husband for twenty years during the Trojan Wars. Although all of Ulysses' countrymen in his native Greece assumed him to be dead and offered up countless suitors for the apparent widow, Penelope kept hope that her husband was alive and remained faithful to him until his return.

Like so many of his generation, Franklin Simmons spent the majority of his artistic life in Italy, where he settled in Rome in 1867 and remained until his death. *Penelope,* following in the American neo-classic sculptural tradition, was carved in marble in Italy, based upon a model by Simmons of around 1880. However, the use of the ornamental Greek Revival chair and the animal hide on which the figure sits evokes the lavish and exotic decor so prevalent in the homes of wealthy Americans during the period that had come to be known as the American Renaissance.

Penelope was made in two sizes, life-size and half-scale. Another small version, dated about 1880, is in the collection of the Portland Museum of Art, Maine, and a third, dated 1907, is on deposit to The Detroit Institute of Arts, Michigan. A life-size version, dated 1903, is also on deposit to The Detroit Institute.

The sculpture retains its original green marble pedestal.

VINCENT G. STIEPEVICH (1841–about 1910)

73. Victorian Interior

Oil on paper, 10 × 14 in.

Signed and dated (at lower left): V. Stiepevich 1880

Born in Venice, Italy, Stiepevich studied painting and decoration at the Royal Academy there under Professor Carl Von Blass. He executed a number of frescoes in Milan and exhibited paintings at the academies in Venice, Milan, and Vienna.

Eventually his reputation became known in the United States and in 1872 he received a commission to decorate the Grand Hall of the Chamber of Commerce in St. Louis, Missouri. By 1877 he had established a studio in New York and exhibited pictures at the National Academy of Design, New York, the Brooklyn Art Association, New York, and the Pennsylvania Academy of the Fine Arts, Philadelphia. He subsequently taught at The Metropolitan Museum of Art school from about 1885 to 1892.

Although the public and private commissions Stiepevich received were primarily for decorative wall paintings and frescoes, he executed genre paintings throughout his career. The subjects he chose for these easel paintings ranged from exotic Venetian and Oriental scenes to subjects more familiar to Americans such as *Victorian Interior*.

The richly elegant and minutely-detailed interior depicted in this painting reflects the artist's early training in, and continuing concern with, decoration, while providing a fascinating visual document of the domestic style of wealthy New Yorkers in the 1880's. The tiger-skin rug, the ornately carved mantel, and the wall decorations are all typical of the fashion of this period.

It is possible that this painting was the one exhibited as no. 178 at the National Academy of Design, New York, in 1880, under the title *Indolence*.

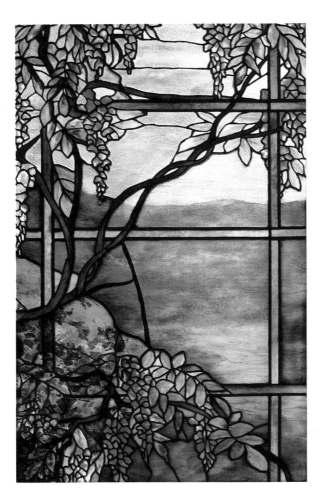

LOUIS COMFORT TIFFANY (1848-1933)

74. Wisteria Diptych

Opalescent glass and pot-metal, left panel: 47¼ × 30¼ in., right panel: 47¼ × 30 in.

Executed about 1905

EX COLL.: private collection, Florida, by 1925; private collection, Ridgewood, New Jersey

With the same conviction as John La Farge, Louis Comfort Tiffany advocated the revival of stained glass in America:

> ... Those of us in America who began to experiment in glass were untrammeled by tradition and were moved solely by a desire to produce a thing of beauty, irrespective of any rule, doctrine or theory beyond that governing good taste and true artistic judgment [Robert Koch, *Louis C. Tiffany: Rebel in Glass* (1964), pp. 78-79].

Both artists, however, took different paths, and after 1885 Tiffany mass produced stained glass and employed an extensive workshop with many assistants. Apart from his major ecclesiastical projects, he incorporated floral patterns and abstract motives into many glass designs. Fond of the wisteria that grew outside the windows of his palatial Laurelton Hall in Cold Spring Harbor, Long Island, New York, Tiffany designed select pieces using this motive. *Wisteria Diptych* was originally commissioned for a private residence in the Midwest.

ELIHU VEDDER (1836-1923)

75. Faces in the Fire

Painted plaster relief, 31¼ × 22¾ in.

Signed, dated, and inscribed (at lower left center):
Elihu Vedder/ROMA/1887

RECORDED: The Detroit Institute of Arts, Michigan, *The Quest for Unity: American Art Between World's Fairs 1876-1893* (1983), p. 168

EXHIBITED: Adams Davidson Galleries, Washington, D.C., 1984, *Marble and Bronze: 100 Years of American Sculpture 1840-1940*, p. 13 no. 8 illus.

This work has been identified by Richard Murray, organizer of the Vedder retrospective exhibition at the National Collection of Fine Arts, Washington, D.C., in 1979, as a unique plaster of Vedder's fireback titled *Faces in the Fire*. At least two bronzes of the subject are known to have been cast. This hand-colored relief, the only known plaster relief by Vedder extant, shows faces which resemble the artist's wife Carrie and their two sons.

About the subject, Vedder wrote: "[it is] filled with a mass of heads looking out of it, that, lighted by the flames or the flickering light of the dying fire or the glow of embers . . . would seem alive and recall lost or absent friends" [Elihu Vedder, *The Digressions of V.* (1910), p. 488].

ELIHU VEDDER (1836-1923)

76. Study for "The Lost Pleiad"

Charcoal and white chalk on gray-green paper,
18⅜ × 9⅞ in.

Signed and inscribed (at lower left): for/The Lost/
Pleiades/E. Vedder

Executed about 1885

RECORDED: *cf.* Elihu Vedder, *The Digressions of V.* (1910),
pp. 484-85 // *cf.* Regina Soria, *Elihu Vedder: American
Visionary Artist in Rome (1836-1923)* (1970), pp. 192, 229,
367 no. D345 // *cf.* Jane Dillenberger, "Between Faith and
Doubt: Subjects for Meditation," in *Perceptions and Evoca-
tions: The Art of Elihu Vedder* (1979), p. 133 fig. 162

EXHIBITED: The Morris Museum, Morristown, New
Jersey, 1984, *American Drawings from Neo-Classicism to
the Avant-Garde*, p. 3 [n.n.] illus.

In 1895 Vedder painted a work titled *The Pleiades*
(The Metropolitan Museum of Art, New York), which
was based upon his illustrations of two years earlier for
Edward Fitzgerald's translation of the *Rubáiyát of Omar
Khayyám*. Regina Soria [*loc. cit.*] wrote about this group of
works:

> From the Rubáiyát drawings Vedder painted sev-
> eral pictures. The first to be sold was *The Pleiades,* to
> Gen. A. Whittier, of Boston, in 1885. Originally
> drawn to accompany quatrains 34, 35, 36, they are
> seven female figures holding up a shining thread of
> light from which glow six stars. The center figure is
> looking with fright at the thread which has broken in
> her hands. This was to become the "Lost Pleiad," a
> theme which Vedder used later in a painting and
> several sketches.

In all likelihood, this study is one of the sketches referred
to by Soria. In it, Vedder began to refine the attitude of
his figure, posed between two vertical elements and wear-
ing a cloth headdress that winds down to her feet. The
location of the finished *Lost Pleiad* is currently unknown.

ELIHU VEDDER (1836-1923)

77. Sleep

Pencil and white chalk on gray paper, 15½ × 12⅛ in.

Executed about 1891

EX COLL.: [Victor Spark, New York]

Ideality was a consistent preoccupation in Vedder's work. Based on his intimate knowledge of Italian Renaissance art, and the work of Frederick Leighton and Lawrence Alma-Tadema, Vedder endowed his female personifications and allegories with timeless beauty and grace.

In its attitude and formal construction *Sleep* relates to *Astronomy* (1892, American Academy and Institute of Arts and Letters, New York) and *Bound Angel* (1891, The Brooklyn Museum, New York). Vedder was a prolific draughtsman; his many sketches were conceived as initial ideas for a picture, or series of pictures on a related theme. In many of these the figure is highly finished, while backgrounds remain vague, suggested by a few concise lines or modeled passages. The idea of sleep, with its intimation of dreams and visions, fascinated Vedder, who had also painted *The Sleeping Girl* (1879-83, Akron Art Institute, Ohio), based on the same theme.

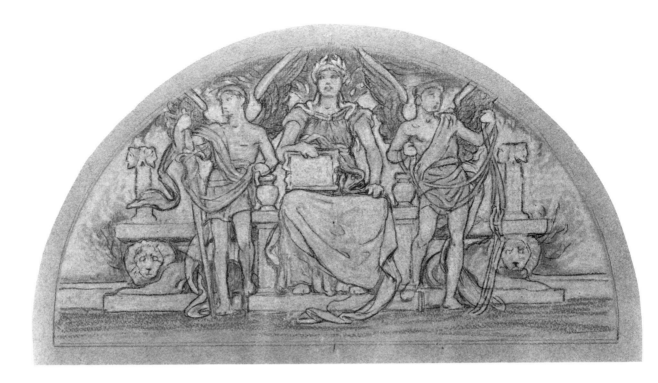

ELIHU VEDDER (1836-1923)

78. Study for "Government"

Charcoal and chalk on blue paper, 7½ × 13⅛ in.
(arched top)

Executed in 1895

RECORDED: *cf.* Herbert Small, ed., *Handbook of the New Library of Congress* (1897), pp. 36-39 // *cf.* Pauline King, *American Mural Painting* (1902), pp. 191-96, 197 illus. // *cf.* Regina Soria, *Elihu Vedder: American Visionary Artist in Rome (1836-1923)* (1970), pp. 219-20, 379 nos. D515-D519 // *cf.* Richard Murray, "The Art of Decoration," in *Perceptions and Evocations: The Art of Elihu Vedder* (1979), pp. 221 illus., 222-23

EXHIBITED: National Collection of Fine Arts, Smithsonian Institution, Washington, D.C., and The Brooklyn Museum, New York, 1979, *Perceptions and Evocations: The Art of Elihu Vedder*, exhib. checklist, [n.p.] no. 315, as *Study for Mural, Government*, lent by the Harold O. Love Family

EX COLL.: the artist; to his daughter, Anita Vedder; to the Harold O. Love Family, by 1960

While Vedder's involvement with mural painting never approached the prolific proportions of Edwin Blashfield or Kenyon Cox, he did receive some choice commissions that brought him recognition in the field. He received his most significant assignment in 1895: to paint five panels for the new Library of Congress in Washington, D.C. Vedder was given the freedom to choose his own subjects; *Government*, *Corrupt Legislation*, *Anar-* *chy*, *Good Administration*, and *Peace and Prosperity* resulted and were conceived as formal decorations with moralistic overtones befitting their location and audience. *Study for "Government"* was Vedder's initial idea for one of the lunettes. Using the Old Master technique to execute his drawing, he worked up passages with chalk on colored paper, bringing up highlights with white. As was his general method with murals, this preliminary sketch was followed by a finished study in oil before the final mural was executed. About the finished mural, Richard Murray [*loc. cit.*] wrote:

> The central panel of *Government* depicts the proper state of rule for a republic, symbolized by the central figure swathed in classical drapery, crowned by a wreath of laurel, and holding a golden scepter (signifying the "golden rule") while she displays Abraham Lincoln's much quoted phrase from the Gettysburg Address [not in Vedder's sketch, as seen here]. The goddess of the republic . . . is seated upon a marble bench supported by posts in the shape of ancient voting urns, symbols of a free and secure election, and by two crouching lions, symbols for a state moored to strength. A winged figure to the left holds the sword of justice and protection and to the right another holds the bridle of restraint and order. In the background are oak leaves, which Vedder used as traditional symbols of strength and vigorous stability.

Vedder's murals were installed in the Library of Congress in 1896, above the doorways leading into the House of Representatives Reading Room. These were his last public murals.

ELIHU VEDDER (1836-1923)

79. Design for Mantelpiece

Chalk, pencil, watercolor, and gold on gray-green paper,
7¾ × 14¼ in.

Signed, dated, and inscribed (at lower center): THIS IS
THE SPACE FOR AN INSCRIPTION:E.V.1899 ·; under each
head (from left to right): FUOCO TERRA AQUA ARIA;
inscribed (on the back): This was the headpiece of a/bench
that stood in Vedder's/studio in Capri in Torre/Quattro
Venti "till" 1935/when the daughter Anita sold the Villa to
Sig. Fliori

RECORDED: Richard Murray, "The Art of Decoration," in
Perceptions and Evocations: The Art of Elihu Vedder
(1979), pp. 185, 186 fig. 232

EXHIBITED: National Collection of Fine Arts, Smithsonian
Institution, Washington, D.C., and The Brooklyn Museum,
New York, 1979, *Perceptions and Evocations: The Art of
Elihu Vedder*, exhib. checklist, [n.p.] no. 264, lent by the
Harold O. Love Family

EX COLL.: the artist; to his daughter, Anita Vedder; to the
Harold O. Love Family, by 1960

In Vedder's art, imagination and vision were never com-
promised by technique and formal perfection. Generating
personal iconography, his work embraced the content
of dreams, cosmology, astrology, and the zodiac. *Design
for Mantelpiece* developed directly out of these interests.
Richard Murray [*op. cit.*, p. 183] discussed this aspect of
Vedder's work:

During the late 1870's and 1880's, Vedder became
much interested in the iconography used in ancient
and Renaissance art, in which mythological and
astrological deities are inseparable. He began to think
of using the old zodiacal figures, signs, and glyphs
not only as decorative devices to satisfy a new popular
taste for themes drawn from earlier historical peri-
ods, but as devices to give cosmic significance to
objects otherwise commonplace.

Using symbolic heads, *Design for Mantelpiece* incorpo-
rates the four universal elements, air, earth, fire, and water,
into a decorative design. The first instance where these
four symbols appeared in Vedder's work was for a maga-
zine cover he designed in 1883 for *The Studio*. From that
time on they continued to reappear in his work, as noted
[*ibid.*] by the same author:

Vedder was so intrigued with this formulation of
universal elements that he used it as his bookplate
c. 1882; much later, in 1899, he altered these figures
somewhat and used them for a mantelpiece, for his
"Omar Cup," and finally, in 1910, for the frontispiece
of his autobiography, *The Digressions of V.*

ELIHU VEDDER (1836-1923)

80. Saint Cecilia

Painted and gilded terra cotta, 11½ × 11¾ in.

Signed, dated, and inscribed (at left border): COPY-RIGHT 1897 BY E. VEDDER; (at lower right): 1897

RECORDED: *cf.* The Art Institute of Chicago, Illinois, *Works of Elihu Vedder* (1901), p. 23 nos. 44 (marble) and 45 (colored), as *Santa Cecilia* // *cf.* Regina Soria, *Elihu Vedder: American Visionary in Rome (1836-1923)* (1970), pp. 385-86 no. S8 // *cf.* The Hyde Collection, Glen Falls, New York, *Elihu Vedder (1836-1923): Paintings and Drawings* (1975), p. 28 no. 52

Vedder made several versions of *Saint Cecilia* in different media, including marble, painted metal, and painted and gilded terra cotta. In addition, a drawing exists of the subject [*cf.* Soria, *op. cit.*, p. 378 no. D506, (n.p.) pl. 41].

BESSIE POTTER VONNOH (1872-1955)

81. The Fan

Plaster, 11⅜ in. high

Executed about 1905-10

EXHIBITED: Hirschl & Adler Galleries, New York, 1982, *Carved and Modeled: American Sculpture 1810-1940*, p. 81 no. 48 illus., as *Standing Woman with Fan*

The fragile charm of Bessie Potter Vonnoh's sculptures of young ladies or mothers and children reflects the artistic idealization of women during the American Renaissance. As in *The Fan*, Vonnoh would often clothe her models in classic dress, suggesting not only the refinement of the sitter, but also adding references to the antique. However, these gentle-spirited young women are not personifications of ideals or goddesses from ancient mythology. Instead, they, like their painted counterparts by Thomas Dewing (nos. 13-16), are contemporary women who embody feminine ideals of the period—beauty, grace, and the privileged life.

According to May Brawley Hill, who is currently working on Vonnoh at the City University of New York Graduate School, a terra cotta of *The Fan* was first exhibited at The Corcoran Gallery of Art, Washington, D.C., in 1910. It was subsequently shown in 1911 at McLees Gallery, and in 1912 at the Pennsylvania Academy of the Fine Arts, both in Philadelphia.

A silvered bronze casting of this work is in the collection of the National Museum of Women's Art, Washington, D.C.

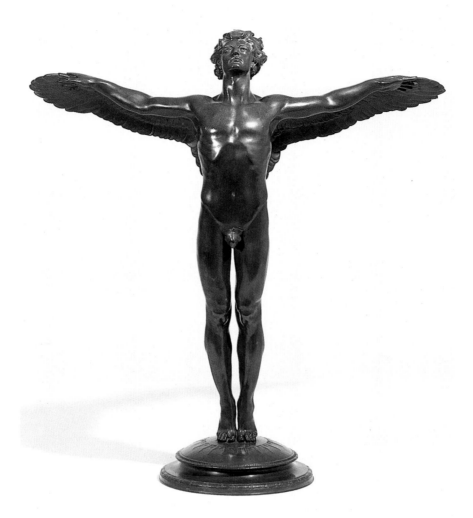

a

ADOLPH ALEXANDER WEINMAN (1870-1952)

82a. The Rising Day

Bronze, dark brown patina, 26¾ in. high

Signed and inscribed (on the base): ©/A. A. WEINMAN FECIT; numbered (under the base): 52

Founder's mark (on the base): -ROMAN BRONZE WORKS- N-Y-

Model executed about 1914-15

82b. Descending Night

Bronze, dark brown patina, 26 in. high

Signed and inscribed (on the base): ©/A. A. WEINMAN FECIT; numbered (under the base): 6 or 9

Founder's mark (on the base): ROMAN BRONZE WORKS N Y

Model executed about 1914-15

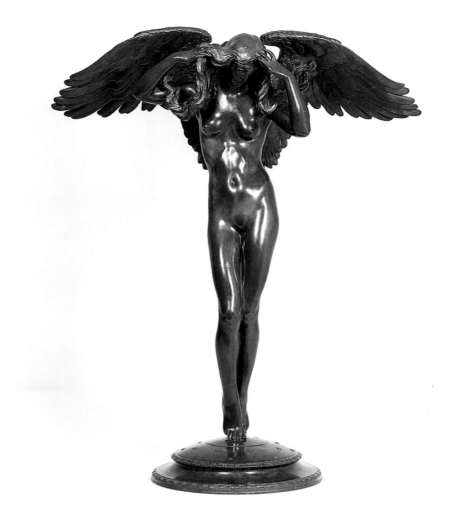

b

RECORDED: *cf.* Juliet James, *Sculpture of the Exposition Palaces and Courts* (1915), pp. 18-19 *The Rising Sun* illus., 20-21 *Descending Night* illus. // *cf.* The American Sculptor Series in collaboration with The National Sculpture Society, *Adolph A. Weinman* (1950), pp. 16 *Descending Night* illus., 17 *Fountain of "The Setting Sun"* illus., 18 *Rising Day* illus., 19 *Fountain of "The Rising Sun"* illus., 61 // *cf.* Whitney Museum of American Art, New York, *200 Years of American Sculpture* (1976), pp. 115 figs. 151 and 152, 349 nos. 319 and 320 // *cf.* The Brooklyn Museum, New York, *The American Renaissance 1876-1917* (1979), p. 228 nos. 271 and 272 illus.

To celebrate the opening of the Panama Canal—and the joining of the Atlantic and Pacific Oceans—one of the great world's fairs was organized in 1915 in San Francisco, California. Like its predecessors in Chicago, Illinois, in 1893, Buffalo, New York, in 1901, and St. Louis, Missouri, in 1904, the Panama-Pacific International Exposition brought together painters, sculptors, and architects in a large-scale collaborative effort.

One of the major outdoor decorations at the San Francisco exposition was Adolph A. Weinman's monumental pair of fountains entitled *The Rising Sun* (or *The Rising Day*) and *The Setting Sun* (or *Descending Night*). Surmounting enormous decorated columns, the pair was installed in the Court of the Universe, designed by the New York architectural firm of McKim, Mead, and White. The building and its courtyard, known as "the meeting place of hemispheres," was 700 feet long and 900 feet wide and stood at the northern end of the fairgrounds, between the Palace of Agriculture and the Palace of Transportation.

Since Weinman's fountain figures were made of staff material, or plaster reinforced with hay or burlap fiber, they are no longer extant. The present bronzes are reductions of the sculptor's working models (57½ in. and 55¼ in. high, respectively) for the exposition figures.

CHARLES ALLAN WINTER (1869-1942)

83. A Sphinx

Oil on canvas mounted on board, 24¼ × 20¼ in.

Signed and dated (at lower left): CHARLES · ALLAN · WINTER 1921

Winter began his art training at the early age of fifteen when he entered the Cincinnati Art Academy, Ohio. Winning the Academy's Foreign Scholarship Competition in 1894 enabled him to study in Paris, where he enrolled in the Académie Julian, studying under William-Adolphe Bouguereau. He exhibited in the Paris Salons of 1896 and 1898, and returned to America in 1898 to teach in St. Louis, Missouri. He moved to New York in 1901 where he worked both as an illustrator and portrait painter. Around 1915, Winter, together with his fellow artists Robert Henri, John Sloan, and George Bellows, began experimenting with a new line of twenty-four pre-mixed color paints developed by the Chicago chemist, paint manufacturer, and artist Hardesty G. Maratta.

Winter's interest in the idealization of women as symbols of purity, coupled with his generation's fascination with Persia and the Far East, are given full treatment in this haunting painting of a young woman holding a ceramic jar. Her distant, yet piercing gaze passes through the viewer, concentrating perhaps on mysterious rituals she alone comprehends. The picture relates to other such works painted during Winter's New York years as *The Crystal* (collection of Mrs. James G. MacLean, Brooklyn, New York), with its shallow picture plane, decorative leafy background, and vibrant Maratta color palette.

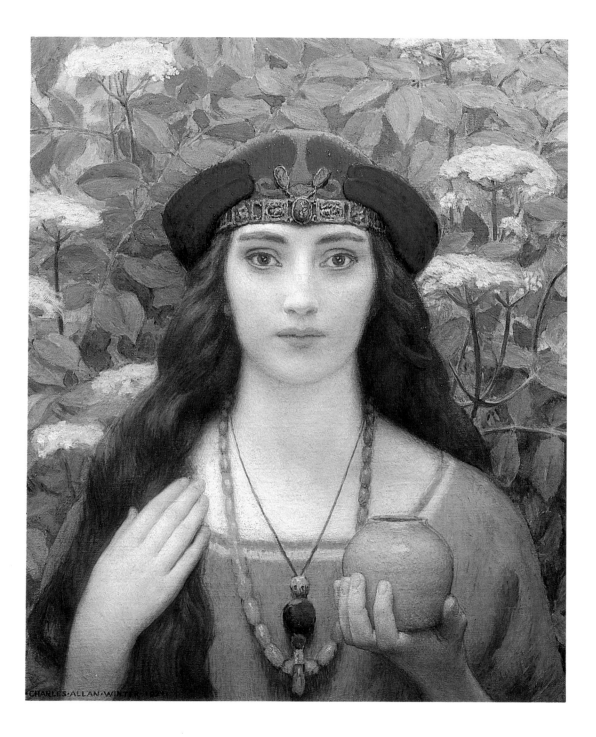

INDEX

All photography by Helga Photo Studios, except
Cover by Jerry L. Thompson
No. 20 by Geoffrey Clements

Typography by Compo-Set, Inc., N.Y.

Printed by Colorcraft Lithographers, N.Y.